D1483756

Photo Developing Volume 1

PHOTO–EDITING AND PRESENTATION
A Guide to Image Editing and Presentation
for Photographers and Visual Artists

Douglas Holleley MFA PhD

CLARELLEN

RIT Cary Graphic Arts Press

C L A R E L L E N
116 Elmwood Avenue
Rochester NY 14611
www.clarellen.com

ISBN 978-0-9707138-5-8

RIT Cary Graphic Arts Press
90 Lomb Memorial Drive
Rochester, New York 14623
http://carypress.rit.edu

PHOTO–EDITING
AND PRESENTATION

Douglas Holleley MFA PhD

CONTENTS

CHAPTER 2
MACRO EDITING SYSTEMS

CHAPTER 3
PRESENTATION

CHAPTER 4
PRESENTATION TECHNIQUES

BIBLIOGRAPHY

INDEX

ACKNOWLEDGEMENTS

The book you are reading is not about improving your photographs. There are no tips or tricks of this nature to be found. Instead, use it to help clarify your content and your meaning—not only to your audience, but more importantly to yourself.
1001 Ways to Improve Your Photography. *Edited by Willard D. Morgan. New York: National Educational Alliance, 1945.*

INTRODUCTION

The main thesis of this book is that the editing and subsequent presentation of your work is no less than the creation of meaning. Very few, if any images (especially the disembodied, de-contextualized artifact/arty-fact we call the photograph) make sense when read as a single image. The very act of photography implies isolation. Individual photographs, for the most part, are an instantaneous and impossibly brief sample out of the continuum of time, space (and indeed life) that surrounds us constantly. It is only when images begin to accumulate and are contextualized within a narrative, series or sequence (or perhaps some form of text) that their message becomes accessible and intelligible.

To simply continue to make images without addressing the context within which they are viewed is to erect a wall of visual noise. Such a wall can easily, almost invisibly, separate the perception of images from our understanding of them.

The second thesis is that the images we make do not necessarily reflect a conscious process of perception and cognition. Instead, like dreams, they can often present us with insights that come from areas of the brain whose functions are more intuitive, even more primitive. The fact that these messages can happen at all in this manner, via a medium that is so mechanistic in nature, is truly a miracle. Yet all too often these messages are ignored in favor of what we know (or think we know) rather than the evidence of what we have seen.

Carefully and respectfully embarking on a process that recognizes, even embraces, this apparent disconnect is the point of editing. For only when a cumulative picture is assembled do our intentions, desires and achievements start to make sense. This is very difficult—but the rewards are great.

Finally, be aware that these various suggestions are just a starting point. Again to use the metaphor of a dream, remember that there are many books, usually located beside the supermarket checkout cash register, which promise to tell us what our dreams mean. On rare occasions they can provide an insight, but such insights are usually over-generalized. Constructing meaning can only occur when the reading of your own personal symbols is specific to you. The techniques described in this book can help, but they are still just techniques. Only you can take the next step which begins with the simple leap of faith that all of the expressions of value that we call our photographs (or images) have a message—intended or not. Therefore, give them the opportunity to be seen and heard.

Above: An image from the Encyclopedia of Source Illustrations, a facsimile volume comprising all of the 266 plates contained in The Iconographic Encyclopedia of 1851. *Hastings-on-Hudson, NY, Morgan and Morgan, 1972.*

CHAPTER I
BASIC EDITING STRATEGIES

INTRODUCTION

All photography is a process of selection. Initially the photographer goes out into the world and selects slivers of time and space. Subsequently, after the images are processed, individual images are selected from the proof sheet and printed. Finally there comes a stage when these images accumulate to the point at which another selection process comes into play. This final stage is called editing. However, this simple term understates the importance of this act. More correctly, it is literally the creation of meaning.

It needs to be understood at the outset that the initial process of selection when making the image(s) is very different from the stages that follow. When one is actually photographing, there is no doubt that it is helpful to have an idea in mind. However, at the same time one also needs a mental set that is a mix of receptivity and intuition. Frequently, judgments must be made in a fraction of a second. Although you might have a plan when setting out to make pictures, once you start, quite often new events and viewpoints are presented that could never be anticipated—and it is good practice to respond to these unexpected occurrences.

In comparison, the processes of selection that follow are far more analytical and conscious. All of the images you made, for whatever reason, are now part of your inventory and should be seen as having equal weight. The serendipitous images (or discoveries) are just as important as the images made with a more conscious and purposeful mind-set. The receptive and intuitive mode necessary to make pictures must now be

tempered with analysis and objectivity. If you can, try looking at your images as if they were made by someone else.

The important question to ask is not, "Does the work say what I wanted it to say?" Instead ask, "Can I take responsibility for what it is saying?" This is a fine but important distinction. Editing, and ordering your work is a creative act with its own consequences and effects. Additionally, it is also a reminder that, from time to time, one will receive new insights and learn new things when one engages with a medium.

In this chapter we will examine a variety of ways to facilitate this process. Firstly we will examine how to maximize the feedback inherent in the totality of your initial response to the world. Following this there is a discussion of the disjunction that can occur between what you intended and what you actually have done. Finally, a variety of editing strategies are outlined that will assist you when organizing your work.

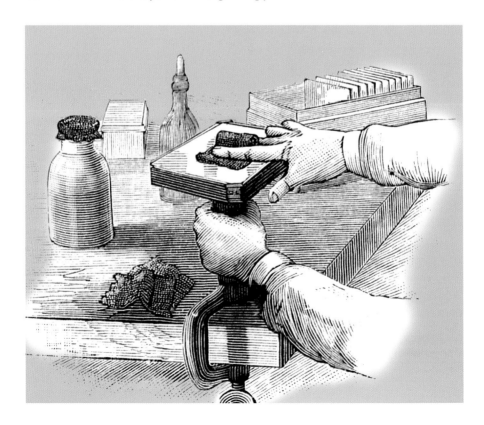

THE INITIAL EDIT

Opposite: A Daguerreo-type plate being polished prior to sensitizing it with mercury vapor. As each image was unique and time-consuming to make, there was no opportunity or need to make hundreds of images to get the one great shot. Courtesy of George Eastman House, Rochester, NY.

When we go out into the world to make photographs, seldom do we select one or two viewpoints, make a couple of exposures and return home content to make one or two prints. More often than not, dozens, if not hundreds, of images are made. Why?

Probably the simplest reason is that we can! Both digital and 35mm cameras permit, even encourage this level of production (consumption?). So the choice is clear: if it is mindless excess, stop it! If however, it is not, then why ignore the totality of the response in favor of a search for the single great shot?

The reality is that every photograph is always an expression of value. Each time the shutter is pressed, a choice is being made. You are saying that what you saw/thought/felt what was in front of the camera was more important than other alternate events/objects/people that could have been photographed at the time. Put another way, seldom do you make a picture of something you either don't like, or know to be bad. Not only that, each of the images was made in sequence where, even unconsciously, each succeeding decision to make an image was conditioned by the frame or frames that preceded it. Why then, when looking at the results of your efforts for the first time are these facts ignored in favor of the search for a single image? It is much more useful to take responsibility for all of the photographs you make, and, at least initially, regard each of them as having equal weight and value.

The point I am making is that every image, and as importantly, every relationship between every image, is valuable data. If you analyze the totality of your response you will receive insights as to what your values are, what kinds of subject matter you tend to prefer, what kinds of visual structures you respond to and/or create, what is the hierarchy of your response, etc.

With this in mind, take a deep breath and in the first instance try to make sense of ALL the data. This includes a careful examination of the relationship between the images, e.g. evidence of repeating themes, shapes or structures, as well as the images themselves.

METHOD

Firstly, when working either digitally or with film—make a decent proof sheet. Looking at your images one by one on a monitor, or worse still, on the camera's preview screen, or even as a (partial) array can never compare to the reality test that is the image printed on a piece of paper. Not only can you not see the totality of your response on the screen, but also pictures look different when printed. Even the most precisely calibrated monitor cannot look like a print. Prints are not backlit glowing specters, but are tangible objects rendered by pigment on paper. It is not necessary at this stage to go into the difference between additive and subtractive color. It is enough to realize that a screen is a mere preview of what the image most likely will look like when printed. (Unless of course you are considering presenting your images on screen as a final product.) You do not, and cannot know for sure, how the print will look until it is rendered on paper.

Below:
Do not be tempted to see the proof sheet as something of little importance, or something that is an intermediate stage and can be hastily, even sloppily made. A good proof sheet provides much valuable data and feedback. Make each image a decent size and spend some time communing with your work. Proof sheet for Robert Blan Boswell's book, The Dream Journey, the Econ River. *2007. See lulu.com*

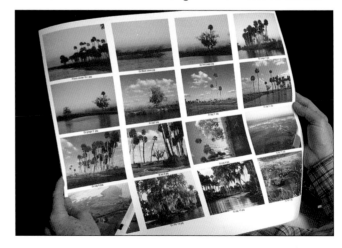

Secondly, it is important to give yourself some decent data to work with. All too often proof sheets are simply not made at all, or are made in a hurry, or are too small to be of any use. In the old days of film they were also often poorly processed and out of sequence. Such strategies give little more than a general indication of what an image might look like if properly printed. As such they become a de facto editing process because the majority of the data is of such poor quality it is overlooked, ignored or invisible.

Therefore, take the time to make a decent sized proof sheet so that your images are at least 2-3 inches wide. Use the Contact Sheet feature in Photoshop and print them on a large size sheet. Resist the urge to search for the great shot and examine the images as a whole.

FINAL THOUGHTS

Consider the long term effect if you simply continue to look for that single great image. Slowly over time the thought will begin to emerge that it is impossible to expose a roll of film wherein each image, or a large proportion therein, has validity. Even when this does happen (and it does happen surprisingly often) I have noticed there is often great resistance to accepting this outcome as having any merit.

Reasons vary: it can seem like cheating, it is statistically impossible, it is not what is being asked for, it is too easy. None of these excuses (more properly perceptual/cognitive blind spots) have any real weight. They are simply bad habits.

Often I have seen examples of wonderful visual interactions with the world which are sustained through entire rolls of film—and as often as not I have watched the student painfully attempt to find the image that's "the best." Even when reassured that all are of interest (and indeed all, even if of the same object, scene or subject are different from each other) it can often take the photographer weeks, even an entire semester, (and sometimes years) to accept with grace the gift that he or she has presented to him or her self.

When you
look at your
proof sheet
and see a
good one,
ask
yourself,

"What
criteria did
I just use to
make that
call?"

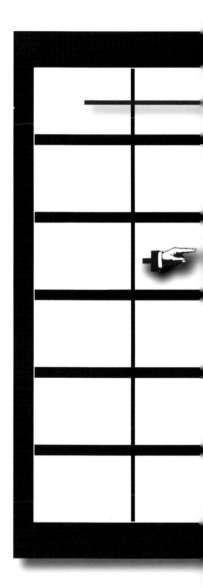

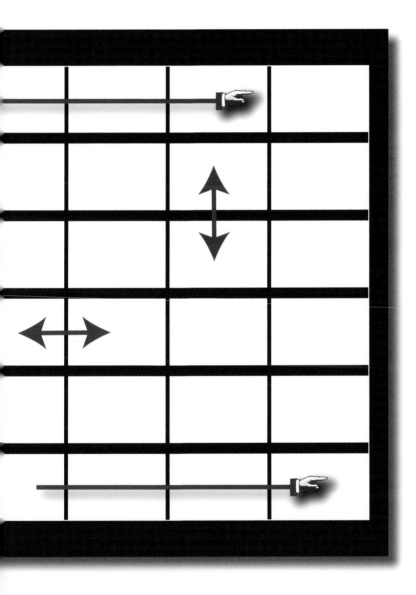

Overleaf: A detail of a digital proof sheet with the (usually white) borders inverted to black. Images by the author.

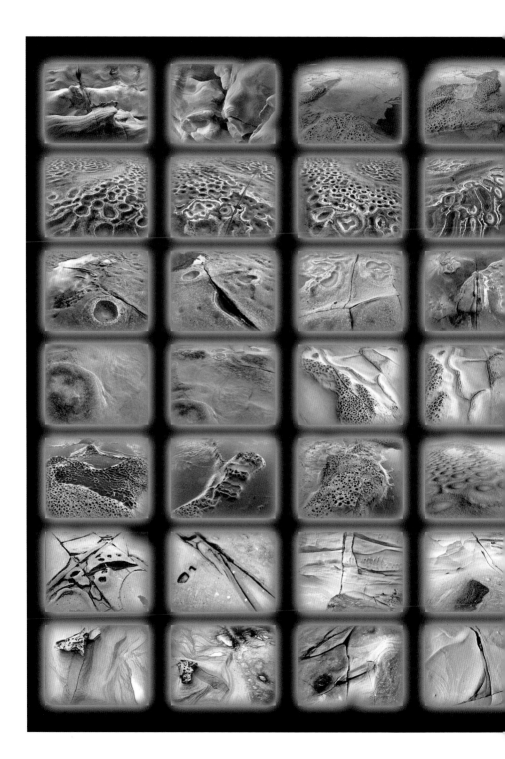

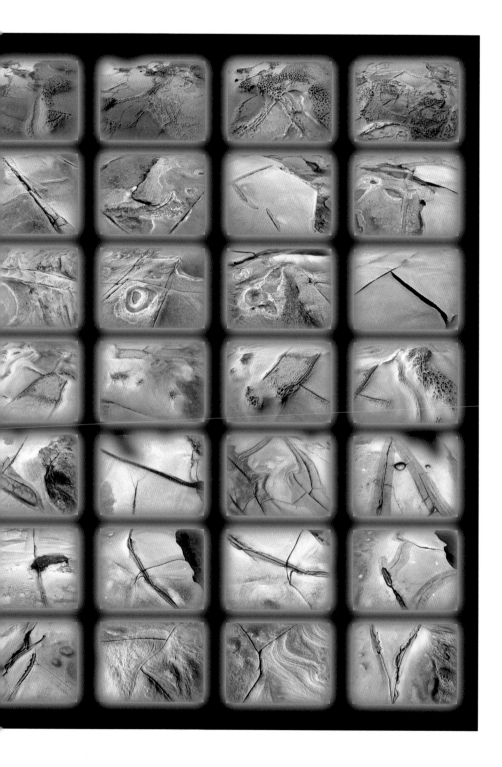

This image is from The Complete Photographer *by R. Child Bayley.*
New York: Frederick A. Stokes Company, c. 1923.

What classical political economy does not see, is not what it does not see, it is what it sees. It is not what it lacks, on the contrary, it is what is does not lack, it is not what it misses, on the contrary it is what it does not miss. The oversight, then, is not to see what one sees, the oversight no longer concerns the object, but the sight itself. The oversight is an oversight that concerns vision: non-vision is therefore inside vision, it is a form of vision and hence has a necessary relationship with vision.

Louis Althusser.[1]

1. *As quoted by Martin Jay,* Downcast Eyes, *Berkeley: University of California Press, 1994.*

INTENTION VERSUS EFFECT

Making images is very different from evaluating images.

2. See the author's book, Digital Book Design and Publishing, *Rochester, NY: Clarellen, 2001.*

Quite often, the first time one has a thought is when it manifests itself through one's medium. As I have said on another occasion, "the word medium suggests there is a process somehow outside of ourselves, that helps us find the most appropriate form of expression. For example, often one does not know one's thoughts until one tries to express them through the medium of speech!"[2] If this can be true for the most direct link between private, internal thought and the external manifestation of that thought, then how much more should it be true for the more complex ideas one addresses when one begins to express one's view of the world with a machine.

What I am suggesting is an attitude to photography which acknowledges that your statement is an interaction between your desires and aims (intention) and the images which are subsequently created (effect). Sometimes your pictures will closely correspond to your pre-visualized notion. Sometimes they will be vastly different. However, whatever they are, they are highly discrete answers to your own visual enquiry and as such are highly relevant to you—no matter how unexpected the result. The critical thing is to accept that when you photograph, in a very real sense you are asking a question of the world, and the photographs are the answer you receive. There is no point saying,

"I will ignore that answer!"

INTENTIONALITY

Intention and effect can be expressed as a continuum. On one hand we have a photographer with a firm idea or concept before the images are made and on the other extreme a photographer with little or no idea in advance what his or her images should be of, look like, or be about.

Pre-defined Concept Open-ended Investigation

Either extreme can be problematical. If you have a very firm idea, then a number of problems can easily arise.

• You may not be able to evaluate your images objectively. The tendency will be to insist they are about what you wanted them to be about even if they are not. This happens particularly when the photographs may be partially what you intended, enough to substantiate somewhat the original idea, but not enough to convince others. This can make you cling stubbornly to your original intention and try to talk the images into fitting the concept, even when some modification may be in order. You can also become paralyzed by agonizing over whether or not you should change your original idea.

• You may run the risk of missing other tangential but important cues and clues which are equally valid and equally worthy of your attention. Thus valuable lines of investigation and other ideas can go unrecognized and remain undeveloped.

• The work can be so successful that it becomes mere illustration. In other words, your idea may be too completely and literally expressed in the images.

Opposite: From the author's book Past and Future Tense, *Rochester, Visual Studies Workshop, 1998.*

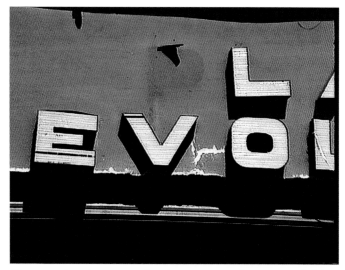

No matter how long one makes pictures, one is always reminded that there is always more to learn. I made the image above in 1996—a time when a long relationship was undergoing a process of bitter disintegration. At the time I looked at this image and thought to myself, "When love goes wrong, it becomes evil." Around eight years later, I looked again. This time I read "evol" as shorthand for evolution. Much better!

Whether this latter interpretation is truer than the original meaning I ascribed to it, I still do not know—and perhaps it does not matter. The real point is that to insist that an image has a fixed and immutable message, or to insist that it conform to a pre-determined intention, is not only confining but in all likelihood incorrect.

On the other hand, if instead you adopt an extremely open-ended investigation then other problems can easily occur.

• You may have no firm criteria to decide the success or relevance of your images.

• You can run the risk of abdicating the essential role of authorship, i.e. taking responsibility for what you have done.

• You can easily mistake activity for work.

Like any continuum (usually disguised as an oppositional duality) most of us will find ourselves moving somewhere between these two extremes. Remember that the mental set one needs to adopt when making images is very different from the one needed when subsequently evaluating the images—it is no wonder discrepancies occur. You therefore have no choice but to accept and embrace the evidence of the medium, be as objective as possible, and trust the process and your eyes.

Below: Image from Pictorial Photography, Its Principles and Practice. *Paul Anderson, Philadelphia and London: J. B. Lippincott and Co., 1923.*

EDITING STRATEGIES

The basic principle of editing is the fact that the moment one image is placed next to another, the meaning of each is modified. If shown two or more images together, the viewer will not see each single photograph as a discrete, isolated image, but will instead attempt to draw connections and inferences based on the totality of the visual experience.

Read the phrase below:

A B C

Now read again.

12 13 14

3. See Zakia, Richard D., Perception and Imaging, Boston: Focal Press, 2002.

Gestalt psychologists[3] term this cognitive imperative to see isolated parts as being connected to a whole, as "closure." It is this principle that underlies the discussion in the remainder of the chapter wherein we address the various ways images can go together. We will start with simple (sometimes even unhelpful) methods and progress to those which are more complex, but ultimately more useful. In all cases the aim is to create and/or clarify meaning—both to the viewer of your work and more importantly to yourself.

Before moving on to a more detailed discussion of various formal strategies, why not simply have some fun by experimenting with spontaneous, intuitive, even quirky juxtapositions? The following exercise was conceived by Bob Jardine of the Birmingham Institute of Art & Design in the UK.

THE THIRD EFFECT

The 'third effect' is what happens when two photographs are juxtaposed—without captions, titles or any other textual clues.

We read meaning into each photograph individually. But we also read meaning into the fact that they have been juxtaposed. This third meaning is highly subjective, shifting and enigmatic. It is an extension of what Roland Barthes called the 'obtuse meaning' in all photographs. It can be compared to the relationship between mise-en-scene and montage in film. The bigger the gap between paired photographs—subject matter, source, intention, genre, time, etc., the greater the third effect.

3rdeffect.net is an online artwork/fanzine/research archive dedicated to exploring this phenomenon—the outcome of an expanding network of global contributors. All are invited to participate in this event.

The photographs can be your own, or found images. They can be color, b/w, horizontal, vertical or square—but they must fit the page. They should not be heavily manipulated—cropping, contrast and saturation adjustments are OK. The photographs should already exist—i.e. not taken specifically for this project. There are enough images in the world. The question is: what to do with them? Any text—signs, billboards, shop fronts etc.—should be incidental and not the main reason the photograph was taken. This is a project about images without words.

If it looks right, it is. Think: "When unlikely images collide..."

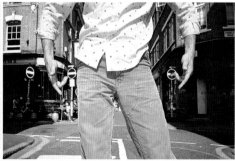

Above: Three image pairs from the 3rdeffect website. Note also how by simply placing more than one pair on the page, other connections are created, not just from side to side, but also up and down. Top: David Viney, Center: John Hodgett, Lower: Jan von Holleben/Courtesy of Peter Halpert Fine Art (janvonholleben.com).

The Third Effect #2 conducted at the Research Center of the
Visual Studies Workshop, Rochester, NY, by Chris Burnett.

The visionary historian and photographic archivist Paul Vanderbilt is the patron saint for
our investigation of the 3rd Effect using a large picture collection. Vanderbilt envisioned
the use of archives as an exploration rather than the routine selection of illustrations
to accompany prescribed arguments. To encourage an open-ended, imaginative use of
pictures, Vanderbilt worked out a long-term habit of creating combinations of images,
usually in pairs, that were unrelated to each other by the usual archival categories, such
as photographer, time period, geographic location, genre, and subject matter. Escaping the
regulation of these controlled vocabularies, the pairings would reveal an unexpected line
of interpretation and lead to larger associative patterns of imagery and ideas.

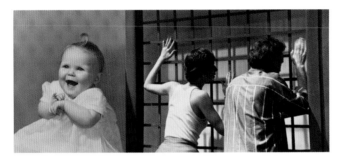

Top: Yichun Lin,
Center: Chris Burnett,
Lower: Sara Segerlin.

SYSTEMS OF INTERNAL LOGIC

- Category or Genre
- Similar Classes of Objects
- Similar Classes of Objects Occupying the
 Same Visual Space When Photographed
- Use of Recurring Visual Motifs
- Color
- Metaphors and Symbols

CATEGORY OR GENRE

This (most basic, and most unhelpful) method is based on the fact that photography can be used for a host of different purposes. The following list, by no means complete, gives some indication of the extent of this practice. Note how all of the categories can be used either as an adjective preceding the word photography or represent some kind of art movement or "ism."

People, Portraiture, Photojournalism, Documentary, Landscape, Nature, Cultural Landscape, Commercial, Advertising, Catalog, Fashion, Scientific, Forensic, Archeological, Spy, Tourism, Family, Fine Art, Naturalistic, Straight, Photomontage, Pictorialism, High Modernism, Bureaucratic or State, Criminal, Propaganda, and its counterpart, Satire.

However, genres are an anathema to photography. Unlike the discrete, highly specific slice of time and space that is the photograph, genres are broad, language-based, generalizations. Not only that, employing them as an organizational device can lead to genuinely problematical situations with profound ethical consequences. By way of example it is helpful to examine the heritage of the term "documentary photography."

Once upon a time there was the world and then one day there was a new way of interpreting it. This new way was

photography. Many serious and committed individuals struggled to persuade these two phenomena to co-exist. In the nineteenth century, Francis Frith packed up his cumbersome wet plate equipment and took large, static images of the pyramids for the delectation of armchair travelers in Great Britain and America. By the mid twentieth century, when equipment became both smaller and more portable, photographers again struggled to depict reality. Great exponents of this art such as Margaret Bourke-White, Weegee, Cartier Bresson, Diane Arbus and Robert Frank devised new ways of re-presenting real-world events.

However, from our current perspective, we now look at the pioneering work of such artists and see it, not as their individual struggle to depict the complexity of the world, but instead a pre-existing genre or vocabulary which we can now simply use. Thus these once highly individual picture-making strategies have now become both signifiers of reality and categorical systems. This is why one frequently hears the phrase, "these are documentary style photographs." Be cautious if you hear such a claim. All too often this is code for "I am claiming coherence by employing a methodology (or look) that is a signifier of an authentic reality."

Much the same thing can be said for work which can be described as landscape, portraiture or still-life photography. All of these categories or genres can subsume an infinite number of specific responses and thus are so vague as to be essentially meaningless. It is much harder, but infinitely more worthwhile, to avoid this kind of categorical thinking altogether. However, if you do this, you will no longer have the dubious luxury of grouping your images in the stew pot of genre. You will instead have to consider the particular ways, particular images can be seen together. This can be very difficult, but is infinitely more satisfying than relying on genre-based, overly-general verbal conventions or isms.

Right: The conventions of documentary photography are so ingrained that in all likelihood the reader can look at these four (picture-wise) empty frames and instantly supply a mental image for each.

An image
of pity.

An image
of conflict.

An image
of threat.

An image
of dignity.

SIMILAR CLASSES OF OBJECTS

This is a variation on the use of genre, but is more helpful as it is more specifically related to the subject of the photographs. Thus, for example, instead of employing the impossibly vague genre of landscape, look to see if you have visual biases or perspectives that are more specific. Do your images investigate a particular location in depth? Are you attracted to details of the geophysical features? Do you have a preference for how you frame these places? Do you tend to see much the same thing in much the same way when you move from one place to another? Carefully look for consistent patterns of response. The more specific (and visual) you can be, the better.

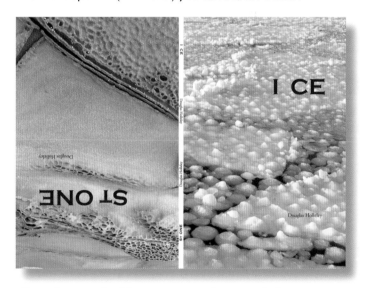

Above: An example of this organizational response. It shows the front and rear cover of a book made from two photographic episodes that were not originally intended to go together. In March 2006 I photographed the ice melting on the shore of Lake Ontario, near Rochester, NY. Three weeks later in Australia I photographed on the shore of a beach called Terrigal, about 50 miles north of Sydney. On returning to the USA and looking at the images I was struck by how my attention was drawn to these two shores. Each image sequence starts from the two front covers of the book. They meet in the middle where the book must be turned upside down to continue reading.

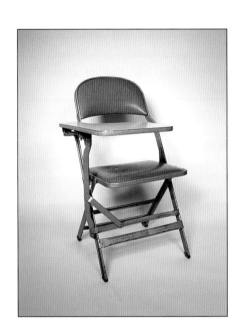

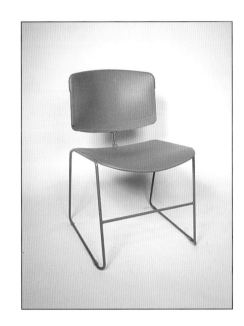

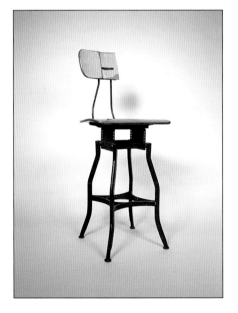

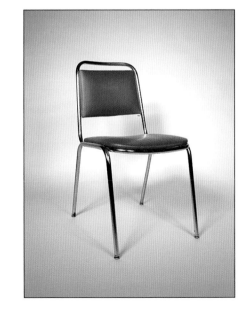

SIMILAR CLASSES OF OBJECTS OCCUPYING
THE SAME VISUAL SPACE WHEN PHOTOGRAPHED

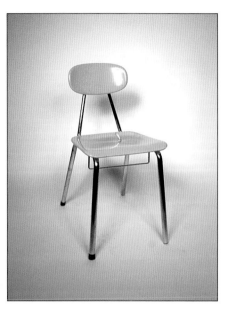

This is a more interesting and complex criterion as it includes not only commonality of subject matter, but also its appearance when rendered by the camera. A well-known example of this kind of system is the work of the German photographers, Bernd and Hilla Becher, whose photographs of industrial structures show simultaneously the similarity of form of the objects themselves within a repeating but sympathetic pictorial space.

Consider also looking for images in your inventory that depict *different objects* which occupy the same pictorial space. In other words, look for commonality of visual structure in addition to simply arranging your work by classes of objects.

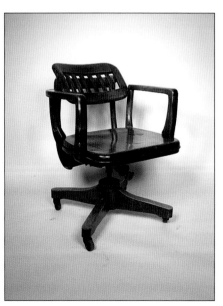

Left: These images by Luke Strosnider exemplify this method of image organization. In addition to their elegant and even sometimes humorous formal properties, they also are a wry comment on the Visual Studies Workshop in Rochester, NY.

The Workshop has survived for many years by making the most of the left-overs of a consumerist society. In this way it has kept alive a variety of economically obsolete yet quite beautiful and important technologies (in particular its film and video collection). This determined policy of making the most of very little also extends to various furnishings scattered throughout the building. As such, the collection of chairs in the Workshop is eclectic to say the least.

Additionally, many of these chairs are, at least from my perspective as an alumnus, closely associated with the individuals who either found or occupied them. Thus Strosnider is showing us not only a collection of curious objects but also presenting us with an extended, coded history of this institution.

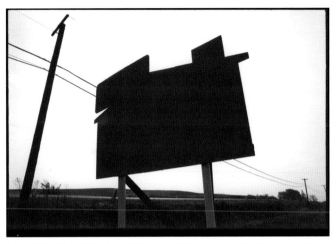

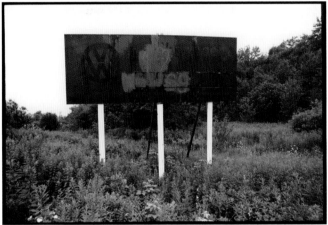

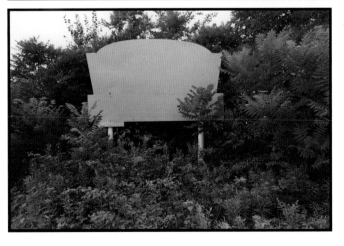

The work of Nathan Lyons is also an excellent example of this strategy— although it has to be stated that Lyons' work also employs many other coexisting schemas which combine to give his work a rarely matched complexity and density. In particular, observe how Lyons ironically uses the motif of the blank billboard to constantly remind the reader of the necessity to not just look at the world, but more importantly, read its many messages.

All images on this spread are from his book Notations in Passing. *Cambridge, MA: M.I.T., 1974.*

USE OF RECURRING VISUAL MOTIFS

Objects

Probably the best known example of this kind of approach is Robert Frank's book, *The Americans.* Frank throughout the work includes images of the flag of the United States (a fairly accessible public symbol) in various places and in various contexts. As such, the flag acquires resonances and invokes feelings far more complex than the patriotic response it would normally elicit. Even more complex and mysterious is his repetition of other less obviously symbolic objects (such as the jukebox) that, by virtue of their rhythmic repetition, assume almost supernatural power and iconic status. Look through your proof sheets to see if this is happening in your work, irrespective of your original intentions. If it is, develop and refine this observational habit by making it more conscious.

Below: Functioning as a visual pun by occupying the same pictorial space as the billboards, the cannon replaces the previously blank messages with a text all its own.

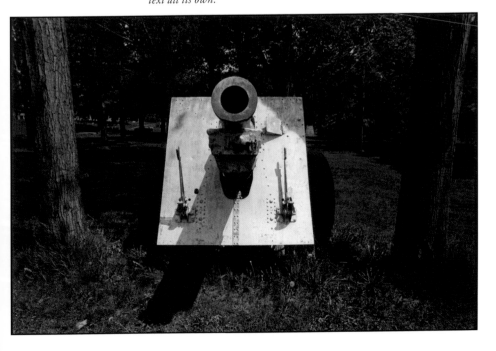

Shapes and Motifs

In a similar manner to the previous examples using objects, so too can you use repetition of shape as a unifying, thematic device. Thus images of quite disparate things can be seen as going together as a function more of their appearance than their nature. This can occur at a macro level wherein the entire picture structure of one image is echoed by others in the group of images, or it can occur in more subtle ways, often in small, seemingly insignificant parts of the image.

Most photographers will, over time, tend to gravitate towards certain distinctive patterns of framing and image composition. However, sometimes it takes a while for these patterns to be consciously perceived and subsequently utilized. There is no easy way to advise you the reader how best to become aware of these devices in your work, other than to say most likely they are already there. Look out also for subsets of these patterns where for example, certain characteristics recur not just across the entire image, but also are repeated in small areas, in different ways, in different materials.

By way of example let us look at another pair of images from the *Third Effect* project.

Opposite: These images show shape repetition at a more macro level than the example(s) to the left. Images from the author's book, A Passing Show. *Sydney: Macquarie University, 1973.*

Left: Paired image(s) by Yichun Lin. Images from the Research Center of the Visual Studies Workshop, Rochester, NY.

Notice how there are several levels of shape repetition. The outlines of the dresses are remarkably similar and the gestures of the two figures also resemble each other. However, most interesting of all is that each photograph has a striped

background. On the left, the stripes are formed by what looks like the slats of a garden chair (which are then, within the same image, echoed by a picket fence behind). On the right, similar stripes are formed by the pleats of what look like stage curtains. Thus two quite disparate classes of objects, by virtue of their appearance when photographed, produce similar if not identical marks on the print. It is these shapes, not those things, that make the match.

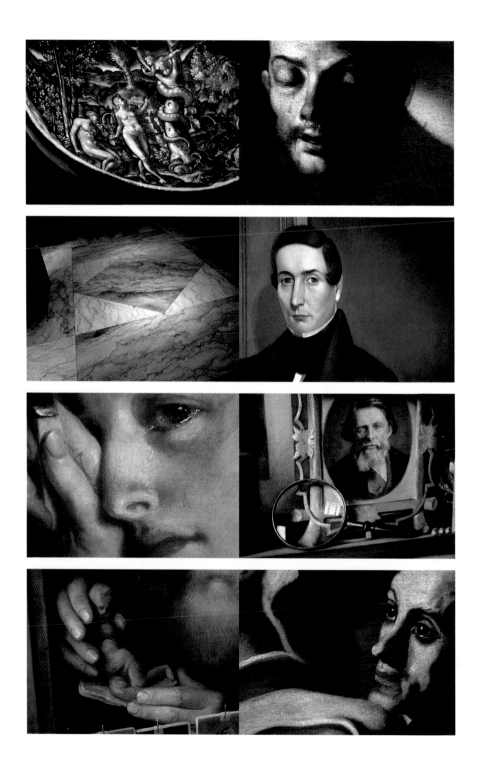

Color

In most photography courses black and white is taught before color.[4] However, this system of progression creates a legacy. If your first few courses were in black and white, then editing strategies which once worked for you may no longer be appropriate. This is because color images work together in a different manner.

Because the eye's response to color is immediate and visceral, color itself is probably the overriding criterion when such images are placed in juxtaposition. Often one sees two images juxtaposed which complement each other in terms of familiar criteria such as subject and visual structure, but clash with respect to the color component. It is almost as if a kind of perceptual blindness has set in and the presence of the color is somehow overlooked or ignored.

It is far better to work backwards from the main element of color, and then subsequently try to make sense of the new relationships formed at other levels. At the end of the day, the color transitions and relationships must be an integral aspect of the work—as important as any objects, shapes or motifs.

4. There was once a good reason for this—learning to process black and white film and paper was relatively easy and inexpensive compared to color. Whether the traditional curriculum will change now that digital photography enables the making of a color image as easy (even easier) than a black and white silver print only time will tell.

Opposite Page: These images are from the book Better Things. *This book examines how artworks are not simply precious objects but also visual messages that can be interpreted and "read" via the act of photography.*

The project began when I was asked to make a book about a notable art collection in Rochester, NY. In the first instance I photographed the physical structure of the building. However, one day I was struck by a very "Hopper-like" image by Guy Pène du Bois which I photographed. Later that evening I looked at the results of the day. These images persuaded me that by extracting details, and by adopting various points of view, I could reveal facets and nuances of meaning in these artworks that were otherwise difficult to discern.

The images accumulated over the period of a year. In the first instance, I paired the images to form diptychs. In almost all the cases, I used color as the common element. I found not only did the paired images work well together at this level, but more importantly, other more complex connections began to emerge as a result. Eventually, by predominantly employing color as the unifying device, four distinct thematic chapters emerged as a consequence.

The point I am making is that color itself is a very useful point of entry into a body of work made with no preconceptions.

From the author's book, Better Things. *Rochester, NY: Clarellen, 2005. Images are details of paintings in the Memorial Art Gallery of the University of Rochester, NY.*

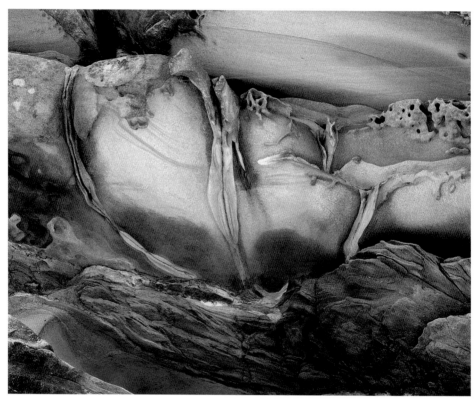

Above: A view of the cliff-face at La Perouse.
Image by the author, 2008.

METAPHORS AND SYMBOLS

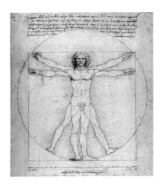

Above: Leonardo Da Vinci, Vetruvian Man, 1492.

Up to this point, the discussion has for the most part made the assumption that the content of your images is directly related to the nature of the objects and/or events depicted in the images. Thus if you are photographing rocks, then the work is therefore about rocks—and dilapidated buildings are no more than that! However, surprisingly often this is not the case. Look at the image opposite of a rock—in this case a section of a cliff-face in Australia. Ask yourself, what is really being depicted?

The clearest analysis of this apparent disconnect comes from the field of psychology. In his discussion on interpreting dreams, Freud[5] coined two very useful terms. He described the events, images and narrative of the dream as being the *manifest content*. The themes, symbols and other psychological forces under the narrative's surface he terms the *latent content*. This is a very helpful distinction.

5. Freud, Sigmund. New Introductory Lectures on Psycho-analysis. New York: Carlton House, 1933.

With this in mind, consider your images as being the manifest content of a dream. What makes things easier is that unlike the shimmering, ephemeral nature of most dreams, photographs remain fixed in time and space, and can be interpreted at leisure. Be aware that although this phenomenon is surprisingly common, equally common is a resistance to accepting these messages when they occur. Just like in our dreams, sometimes our photographs show and tell us things we don't want to either see or hear.

There are many levels of correspondence between the manifest and latent content. The most helpful vocabulary to describe this class of relationships comes from the field of linguistics. Paradoxically, these language-based terms are described in a very visual manner as being "figures of speech." The main relationships are: simile, metaphor, metonymy and synecdoche. These relationships can then be employed to embrace more complex systems such as the allegory and the equivalent.

To each in turn:

Simile

Similes are the simplest of these relationships, so simple in fact that they are more a convention of language rather than a true figure of speech. In a simile, one object is explicitly compared with another and all the terms retain their original (literal) meaning. Thus, A is like B. For example "My love is like a rose." In visual terms a pair of images with similar forms such as a minaret juxtaposed with a space rocket is stating (or more correctly showing) that the former is like the latter.

Metaphor

In comparison, a metaphor states that A is B or substitutes B for A. An example of an explicit metaphor is Shakespeare's line from *As You Like It:* "All the world's a stage." In visual terms, an image of a piece of clothing could be a representation of yourself, either now or in the past, depending on the item of clothing selected. More complex inferences can be drawn depending on how the item of clothing was arranged and illuminated. Even more interesting is the possibility that another subject altogether could be photographed in such a way that looks like a piece of clothing, which furthermore suggests a third idea or personae—such as yourself.

Right: One of the more than 300 synecdochical images Alfred Stieglitz made of Georgia O'Keeffe. Stieglitz was a fervent promoter of the idea that to convey the complexity of the (any) subject, more than one image was essential. "To demand the (single) portrait that will be a complete portrait of any person," he claimed, "is as futile as to demand that a motion picture be condensed into a single still." Alfred Stieglitz, Georgia O'Keeffe, 1918. Courtesy of George Eastman House.

METONYMY

This is a situation in which an attribute of a thing or something related to it is substituted for the thing itself. Thus "Hollywood" conjures up images of the film industry, lifestyles of the rich and famous etc., while the "Pentagon" evokes images of defense and the armed forces. Visually, a photograph of either the Hollywood sign or the Pentagon itself would function in a similar manner. One way to express this schematically might be: A is (or stands for) ab and/or ac and/or ad.

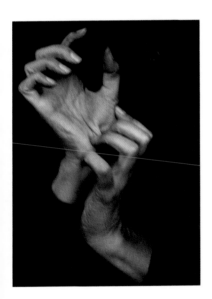

SYNECDOCHE

This concept is very similar to metonymy, the difference being that a part of a person or thing is used to designate the whole. Thus in language, a "set of wheels" can mean a car or "new threads," a new outfit of clothes. In visual terms, Alfred Stieglitz's extended portrait of Georgia O'Keeffe could be seen as an example of the use of the synecdoche. Frequently he photographed parts of her body, especially her hands, to suggest attributes of her personae as a whole. Diagrammatically one way this might be expressed is: ^ or / is (or stands for) A.

ALLEGORY

Allegory is a form of extended metaphor, in which objects, persons, and actions in a narrative, are equated with the meanings that lie outside the narrative itself. The underlying meaning has moral, social, religious, or political significance, and characters are often personifications of such abstract ideas as charity, greed, or envy. Thus an allegory is a story with two meanings, a literal meaning and a symbolic meaning. (See overleaf.)

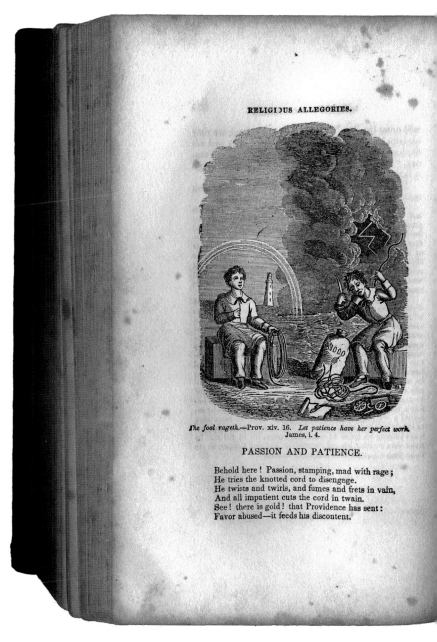

RELIGIOUS ALLEGORIES.

The fool rageth.—Prov. xiv. 16. *Let patience have her perfect work.*
James, i. 4.

PASSION AND PATIENCE.

Behold here ! Passion, stamping, mad with rage ;
He tries the knotted cord to disengage.
He twists and twirls, and fumes and frets in vain,
And all impatient cuts the cord in twain.
See ! there is gold ! that Providence has sent :
Favor abused—it feeds his discontent.

*Above: Allegories are often religious or moral in theme, and didactic in nature.
The above example illustrates the value of patience—certainly one of the most
gracious (and useful) of the virtues—especially when editing and presenting one's
work. As a further benefit, the patient text is a useful example of image analysis.*

RELIGIOUS ALLEGORIES. 233

His soul a tempest—storms around him rise ;
Thunder and lightning shake the trembling skies :
A troubled ocean—white with foaming spray,
Whose restless waters cast up mire and clay.
 But mark the contrast ! Patience much at ease,
Th' intricate cord unravels by degrees.
No bags of gold has he. But what is more,
He has content—of this an ample store ;
While the bright Rainbow, sparkling in the sky,
Is pledge to him of future joys on high :
His soul a calm—by mellow light caressed ;
A placid lake—whose waters are at rest.

Two very different characters are here presented
to our view : Passion, storming, wild with rage—
Patience, calm and tranquil. For some time, Passion
has been endeavoring to unravel a hank of entangled
twine or cord, In his great hurry, he entangles it
more and more. It is full of knots ; he grows hot
with rage ; his face is miscreated ; he wears the as-
pect of a fury. Stamping with anger, he tramples
upon some toys that lay near him, and breaks them into
pieces. A bag of gold is seen standing at his side.
This only feeds his pride ; it makes him more outra-
geous to think that *he* should have such work assigned
him. A tempest is seen to arise behind him ; the
clouds gather blackness ; thunders roll ; fearful light-
nings glare around. This is to show the state of his
mind—wild, fiery and tempestuous. He is also fully
represented by the troubled sea, seen in the back
ground. Tumultuous it tosses its foaming billows ;
its restless water casts up mire and dirt. So his
troubled spirit, agitated by the tumult of his passions
gives utterance to oaths, blasphemies and impreca-
tions. Miserable youth ! The fire of hell is en-
kindled within him !

 Patience, on the other hand, sits with unruffled
composure. He, too, has had the same work assigned

Holmes, William and John W. Barber Religious Emblems: being a series of Em-
blematic Engravings with written explanations, miscellaneous observations and
religious reflections designed to illustrate Divine Truth, in accordance with the
cardinal principles of Christianity. *New York: George F. Tuttle, 1860.*

THE EQUIVALENT

All of the above terms (with the possible exception of the simile) can to a degree be subsumed under the term equivalence. This notion was proposed by Stieglitz in the 1920s and 40 years later codified and promoted by Minor White. This term is very similar to metaphor and can encompass the more specific relationships of metonymy and synecdoche. However, both Stieglitz and White would say it is something more than mere metaphor.

To quote White, "When the photographer shows us what he considers to be an Equivalent, he is showing us an expression of a feeling, but this is not the feeling he had for the object that he photographed. What really happened is he recognized an object or a series of forms that, when photographed, would yield an image with specific suggestive powers that can direct the viewer into a specific and known feeling, state or place within himself."[6]

In other words, White is claiming that an image can resonate in the mind of the viewer in such a way as to replicate the state of mind the photographer was experiencing when the image was made. He does not go so far as to claim that this is evidence of a universal visual language—but it is apparent that he admits the possibility of such an absolutist ideal.

Whether this is possible, likely, or even desirable is not the point. The fact remains that the search for such an ideal—no matter how simplistic it might seem in relationship to more recent theories that emphasize relativity of meaning and the complex inter-relationship between language, cognition and vision—accepts and indeed emphasizes that photographs can have as their communicable content, sets and indeed sub-sets of visual messages which can often bear only a peripheral relationship to the objects and events depicted therein.

6. See Lyons, Nathan, (ed.) Photographers on Photography. *Englewood Cliffs, NJ: Prentice-Hall, 1966.*

It is perhaps a paradox to say that this image is an example of an equivalent. If the concept has any validity at all, then there are as many equivalents as there are both artists and states of mind. However, like many specific concepts, the first to claim ownership often achieves the status of becoming the default collective noun. For example, one seldom reaches for a soft, absorbent, by-product of the forest industry—but almost always for a Kleenex.

Thus paradoxically, and in direct opposition to normal practice in the evolution of the English language, in this instance a verb became a noun. What should have been a methodology and an attitude to the nature and function of the image evolved into a stylistic convention.

This image by Walter Chappell is an equivalent by claim, by intention, and by "look." Chappell intimately understood the beauty and gravity of this idea and made images to support its validity. The picture above is one of his transcriptions of an inner mental state.

Without a doubt it may be read in this manner—within the norms of this idea, or in light of the above practice. However, as remarked before, there are many types of mind-set, all equally capable of being expressed in a manner equivalent to their state.

Instead, look at the idea behind, not the commonly accepted manifestation of, the equivalent. It is not about Stieglitz, or White, or Chappell—or even a school of thought of the mid-20th century. It is about the very real possibility that abstract thoughts and ideas may have (and even create) corresponding, equivalent, shapes and structures in the real world.

Above: The urge to classify and organize the complexity of life has been a preoccupation of men (sic) for centuries. Whether it is a useful practice or mere vanity depends much upon your point of view and innate sensibility. However, as the above image suggests, it is also capable of taking on a life all its own. Direct scan by the author, Periodic Fable, *from the book,* Love Song, *Woodford: Rockcorry, 1995.*

CHAPTER 2
MACRO EDITING SYSTEMS

There is no more surprising, yet in its naturalness and organic sequence, simpler form than the photographic series. This is the logical culmination of photography. The series is no longer a "picture," and none of the canons of pictorial aesthetics can be applied to it. Here the separate picture loses its identity as such and becomes a detail of assembly, an essential structural element of the whole which is the thing itself. In this concatenation of its separate but inseparable parts a photographic series inspired by definite purpose can become at once the most potent weapon and the tenderest lyric.

Telehor 1–2. Moholy Nagy. 1936.

INTRODUCTION

As the above quote implies, a thoughtful effort to address the totality of your finished work is preferable to an often-quixotic search for the Great Image. Besides, in many ways it could be argued that the world has enough great images—but whether we have a concomitant level of understanding of them is something else. At the end of the day our task is to create meaning. To do this we need to create a context within which our images can be both seen, and more importantly, interpreted and understood. Most commonly this context occurs as a function of putting a number of individual images together, ideally in such a way that the whole is greater than the sum of the parts.

To this end we will now discuss organizational structures of a more macro, rather than picture-to-picture, nature. Be aware that these systems have two functions. The most obvious of these is to simply present the work to the viewer. More importantly however, is the fact that in responding to the demands imposed by these systems, the actual content of the work may be clarified by and to, one's self.

- Grouping
- Narrative
- The Sustained Metaphor or Sequence
- The Array
- Assemblage
- The Moving Image
- Diagrammatic Systems

Simply throwing stuff together is unlikely to work. Organizing one's images is more than putting a few prints in a box or up on the wall. It is literally the opportunity to create, or more correctly discover, meaning. The illustration above is from Paul Jacob La Croix Military and Religious Life in the Middle Ages and at the Period of the Renaissance. *London: Bickers & Son, 1870.*

GROUPING

1. See Smith, Keith Structure of the Visual Book. Rochester, NY: keith smith BOOKS, 1995.

The simplest way to put images together is to group them. However, a group is much like what Keith Smith[1] would call a "list." He uses this term to emphasize the fact that a group of images remains pretty much a collection of related, but not inter-related, images. In other words, the images can be looked at in any order and there is no cue or clue to suggest any particular viewing order is any better than another. Even to call such a group a list implies more order than there actually is. More often than not a group is little more than a bunch of stuff.

Visually it can be depicted thus:

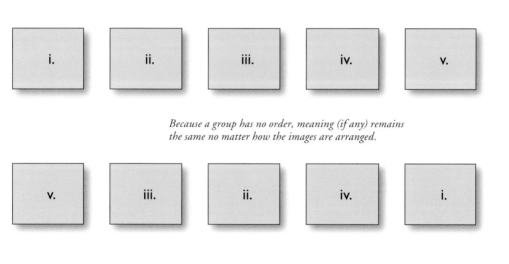

Because a group has no order, meaning (if any) remains the same no matter how the images are arranged.

Thus grouping falls short as an organizing system because it does not consider the vital element of inter-relationship and order. It is critical to consider how your work unfolds to the viewer. Ask yourself, "What does the viewer see first? How does the experience of viewing the work progress and develop? What happens when two or more specific images are placed together in a specific order? How does the experience finish?"

The following strategies address these questions.

ON AUTHORSHIP

Should you decide to leave grouping behind, consider how one's thinking changes when, instead of aiming to be an artist, and make art, one considers oneself to be an author and make a statement. Although the word "authorship" tends to be associated with literary rather than visual modes of expression, it is a very useful concept. This, however, can still be a subject of debate. For example, a perfectly legitimate response could be:

"Authorship is an outmoded concept steeped in the modernist paradigm. It represents a world view analogous to the lonely artist/genius locked in his or her garret diligently working while waiting for the muse of inspiration and greatness to descend and inform the individual as if he or she was personally party to the secrets of the universe. From a post-modernist perspective, notions of individual insight are not only outmoded, but patently false. None of us are islands. Instead we swim in a sea of influence, culture and language. It is this milieu that creates. There is no originality and no personal conduit to truth. To make personal claims of this nature is nonsense!"

To a large degree this is true. Even the invention of photography itself supports this argument. How else do we explain Fox Talbot in his stately home in England, Daguerre in the back room of the Diorama in Paris and Niépce and Bayard elsewhere in France, stumbling on to the same concept at the same time? Not only that, they each stumbled upon it using different means, even though at the end, the production of that artifact we call a photograph was the eventual outcome in all cases.

But to return to the debate. In response I would say:

"All this is true. I do believe that authorship is as much without as it is within. However, the individual must function as a kind of filter. Otherwise these forces remain a swirling mass of potential."

Opposite: Images (or are they text?) by the author, 2004.

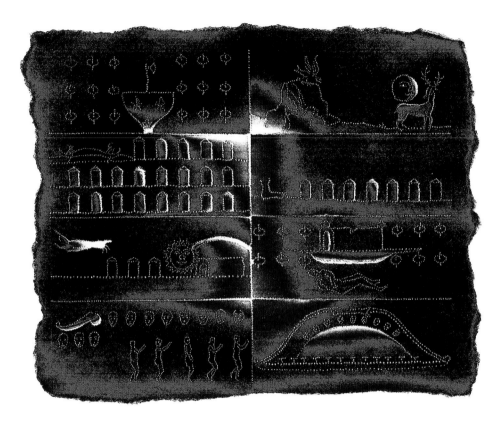

*In the past, images were most
commonly employed to tell a story
in pictographic form. In other
words, there were language-like
conventions for both drawing and
subsequently reading the text.
In this image the story describes
an American Indian war party's
raid on a neighboring tribe.*
Dream Map, *1995. Direct
scan by the author from the
book,* Paper, Scissors and Stone
Woodford: Rockcorry, 1995.

THE NARRATIVE

In a narrative, the order in which the images are viewed becomes important, even critical. However, as the word suggests, it is analogous to telling a story, and therein lies the rub, for to tell a story implies a verbal, rather than visual, construct.

The main quality of a narrative is its forward progression in time.

A.	B.	C.	D.	E.

You will notice that one image leads to another and another in a forward direction. Quite literally it illustrates how a story unfolds. However, you most likely will find that if you attempt to tell a story in this manner with photographs, especially either in a book or an exhibition, there will be problems. There are a number of reasons for this.

The first reason is that narratives work best if you can create a sense of suspense. And to create suspense you need to introduce the quality of (linear) time. This is why the most successful visual narratives using photographs are best seen in cinema (especially early silent movies). Cinema relies on movement and action to propel the story forward. Such properties are alien to still photography. Even movies made entirely of still photographs (e.g. La Jetée[2]) of necessity place the individual images within a linear time line.

Related to the above is the presence of dialog and/or soundtrack. Movies, even comic books (e.g. THWACK! POW!) possess this quality in abundance. In comparison, there are no

2. La Jetée. *Chris Marker, Director, 1962.*

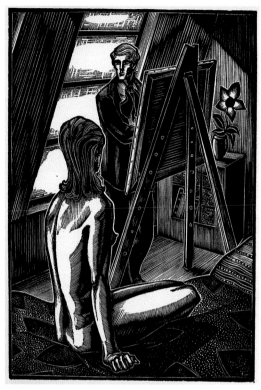

These are the first four images, in order, from Chapter III, The Brand, *from* Gods' Man, a Novel in Woodcuts *by Lynd Ward. The narrative unfolds entirely in images. In the previous chapter the protagonist of the story, a young artist, is seduced by a beautiful young woman. In this chapter however, the artist realizes it is not he the woman desires, but instead his money and/or his soul.*
New York: Peter Smith, 1929.

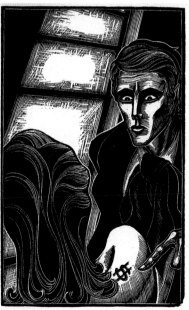

conventions in the current vocabulary of photographs which even vaguely resemble the function of a sound track in the movies, or correspond to the dialog balloons and visual sound effects which are part of the vocabulary of comics. Instead, still photographs emit an almost tangible silence—a function of their ability to provide the privileged perspective of a disembodied and un-hearing eye

Finally, photographic narratives are often just too real to be believed. The cartoonist and author Scott McCloud[3] claims that hand-drawn characters are the best means of creating a visual narrative. He argues that their higher degree of abstraction permits the reader to identify with them in a way not possible if they were rendered in a highly realistic, photographic manner. Some beautiful and original examples of this phenomenon can be seen in the work of Lynd Ward (see opposite page). Ward constructed many extended visual narratives (he called them novels) in a sustained burst of creativity during the middle of the last century. Although his images are rendered in black and white, they are different to photographs in the sense that his characters are drawn with sufficient detail to be believable, and recognizable from scene to scene, but not with so much detail that the viewer forever sees them as a discrete and hence eternally unknowable other. McCloud in his analysis of the comic book sees this abstraction of form as the main way a reader engages with a visual story. He goes so far as to say that the more the character is abstracted, the more you can literally identify with it, rather than simply remain a witness to its adventures.

Thus if attempting a narrative, adopt an approach in which these qualities are not seen as drawbacks but opportunities. Why not present your work as a film? Why not introduce dialog and soundtrack into such a film? If working with books, why not introduce dialog or other text? Why not vary the size and configuration of your images on the page? Why not digitally simplify and abstract the features of your characters?

Such suggestions may offend the purist. However, if you have something to say, why not use all means necessary to get your point across?

3. McCloud, Scott. Understanding Comics. *New York: Harper Collins in association with Kitchen Sink Press, 1994.*

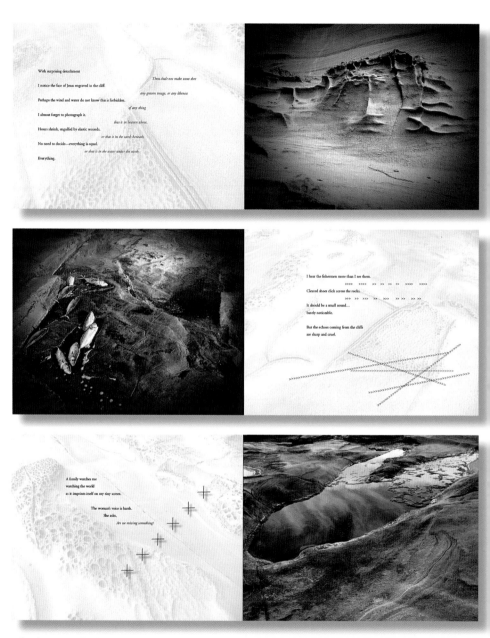

The three spreads above are from the author's book, Veronica. *This book is a hybrid of the narrative and the sequence. The images were permitted to coalesce around the essentially visual notions of form, subject matter and visual space. However, at the same time they tell a story of creation, gleaned from the marks on the very face of the earth—the oldest and biggest book of all. Like Ward's book, there is minimal text—a poem at the beginning and then chapter headings. Rochester, NY: Clarellen, 2006*

THE SUSTAINED METAPHOR OR SEQUENCE

4. For a poetic introduction to White's views on the creative possibilities offered by the sequencing of imagery see Mirrors, Messages, Manifestations *New York: Aperture, 1969.*

5. Keith Smith has codified many of Lyons' thoughts on this matter. See Structure of the Visual Book. *op cit.*

There is another level of organization, similar to the narrative in the sense that the images are fully interdependent and their order of viewing is important, yet is even more complex. This is the notion of creating a sustained metaphor over a number of images, or as Minor White[4] and Nathan Lyons[5] would say: create a sequence that transcends the strictly linear and progressive device of storytelling. Probably a good way of describing this method would be to think of it in terms of "showing," rather than "telling." In practical terms, a sequence usually employs a variety of picture-to-picture relationships rather than any one alone. Thus a well constructed sequence may use classes of objects, classes of visual structure, repeated motifs, in addition to subsets of these strategies as need be.

A. c.	B. a.	B. d.	C. a.	D. b,c.

Above: The capitalized letters indicate the main themes or shapes of each image. The lower case letters represent echoes, references or harbingers of these larger, more directly expressed ideas.

You will notice that the sequence emphasizes a complex web of interactions among all of the component parts of its structure. Rather than tell a story, the sequence aims to construct over time, through the use of a number of images, a series of complex, composite mental images, sensations or thoughts, within the mind of the viewer.

CHARACTERISTICS OF THE SEQUENCE

1. The simple idea behind the sequence is reflected in Moholy Nagy's quote at the beginning of this chapter. Put simply, a finished work consisting of the accumulation of a number of images provides the opportunity to more fully express one's thoughts. Put even more simply, more can indeed, be more. Thus the sequence encourages the maker to enjoy the fruits

of a process of patient and sustained concentration. There need be no hurry or rush. Embrace the complexity this forum offers and take the time to say all that needs to be said.

2. Like a narrative, a successful sequence requires that the way the work is revealed to the viewer is carefully considered. This is particularly the case if one is presenting one's work in a book. However, the same principles hold true for either portfolios or exhibitions. It is true that the exhibition does not offer the same opportunities for progressive revelation as does a book. In this case you can only make the images work with and within the space as best you can (see pages 79-81).

3. Unlike the narrative, which as a general rule reinforces the concept of linear time, the sequence can question the very nature of time itself. In this forum, time can be cyclical, elliptical, recurring, anticipatory and sometimes even suggestive of parallel levels of reality.

4. The sequence requires that you have a good grasp of the formal and metaphorical relationships between images discussed in the previous chapter. Not only that, it provides the opportunity to combine these relationships to make more complex connections.

In conclusion, it is essential to appreciate that sequencing your images is an iterative process. This is a term borrowed from the field of computational mathematics. An iterative method attempts to solve a problem by finding successive approximations to the solution starting from an initial guess or hypothesis. This approach is in contrast to direct methods, which in mathematics attempt to solve the problem in one shot, or in the visual arts by seeking the "great image" or telling a story with a pre-determined plot and/or outcome. Sequencing is best thought of as a conversation with your work—and like any good conversation there is a time to speak and a time to listen. In practical terms, find a large space with a clean floor, and actively interact with your work.

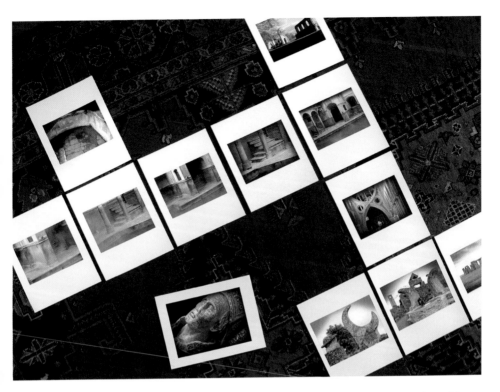

The reader may wish to consider adopting the approach devised by
Ed Leppler. Leppler was a thoughtful educator of young children.
He devised a number of intriguing games that asked the child to
read, if not understand, visual images—rather than use them as a
device to learn to read words. Of these, his game "Picture Scrabble"
is particularly useful. Each player is dealt a hand of some 10 or so
images. The object of the game is to place images together in much
the same way you place Scrabble tiles together. Like Scrabble, if a
tangent presents itself, then start another line of images and place them
perpendicular to the initial thread. Each player in turn, places an
image next to the previous picture. If there is no dissent, the following
player places another image. If however, an objection is raised, the
player who placed the questioned image must explain why he or she
chose to place that particular image in the sequence.

However, one does not need to be in a group to effectively utilize
this strategy. Try this at home with your own work. While doing this,
do your best to pretend that it is not your work but instead that of
someone else. Do your best to put aside your memories or intentions
and give the pictures your permission to do the talking.

Images by the author.

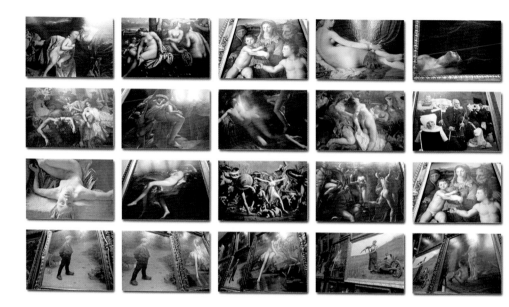

Above: An example of a large scale array by Joan Lyons. In the gallery the effect on the viewer was almost overwhelming as each array occupied an entire wall. To appreciate the scale, each individual image is 16x20 inches. Observe how, in her piece Representations, *she creates complex relationships that work not only from side to side but also both up and down and diagonally.*

THE ARRAY

The previous two methods, for the most part, imply that the images are arranged in a line, either on a wall as a single strip, or in a book or portfolio where the line is a sequential, even consequential, path through time rather than space. However, there are many other possibilities available, especially when one is working to present the finished product in a three dimensional gallery-like space. In such a space, picture relationships need not be limited to one following another. Instead, relationships (much like they present themselves on the contact sheet) can be not only side-to-side, but also up and down, diagonal, or even in a circle.

The following diagram illustrates one such arrangement.

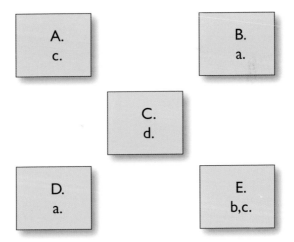

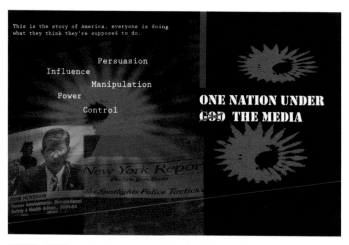

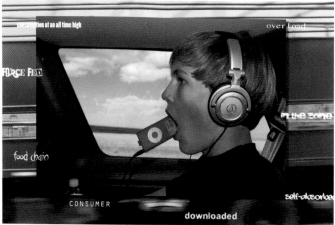

Left: Three spreads from a book by Barbara Platts entitled, I'm Still Learning Things I Ought to Know by Now!, *Anderson Ranch, CO, 2007.*

ASSEMBLAGE

Perhaps as a result of websites such as MySpace, a new tolerance of complexity has been introduced into the issue of placing pictures together. This form may be represented diagrammatically as follows:

Looking at it in this form, one is struck by how much this level of organization resembles the bedroom pin-up boards of childhood. These wonderful, and indeed highly personal collections of images, quotes and souvenirs are probably our first foray into image-editing strategies.

Right: Apart from the pin-up board, other historical precedents come to mind. New York State Fair Side-show Banners, *image by the author, 2007.*

THE MOVING IMAGE

This strategy is addressed in the following chapter as a presentation form which could be applied to pre-existing work. However, it is worth considering using this form before you begin to construct your statement. If you should attempt to use still images in a movie-like manner, be aware it will require an enormous amount of effort and concentration.

The illustrations on this page will give you some idea of what is involved. In addition to the story line, you will also need to consider set construction, character appearance and costume, soundtrack and the sheer number of images needed to construct a credible narrative (and if desired) the illusion of full movement.

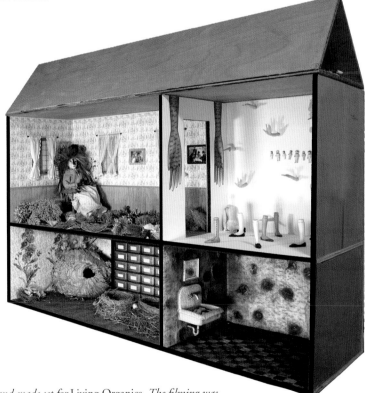

The hand-made set for Living Organics. *The filming was conducted in all four of the rooms. The plywood house is 37 inches tall, 44 inches wide and 14 inches deep.*

Living Organics *is a ten minute character and drawing, stop-motion animated digital movie, composed of 18,000 single photographs.*

It was shot using a Canon EOS Digital Rebel camera. The photographs were imported into the computer, sequenced using Quick Time Pro and edited in Final Cut.

Kiera L Faber, 2007.

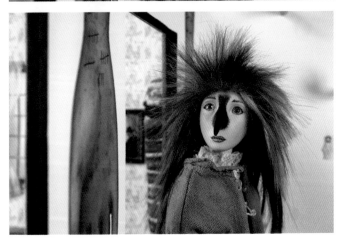

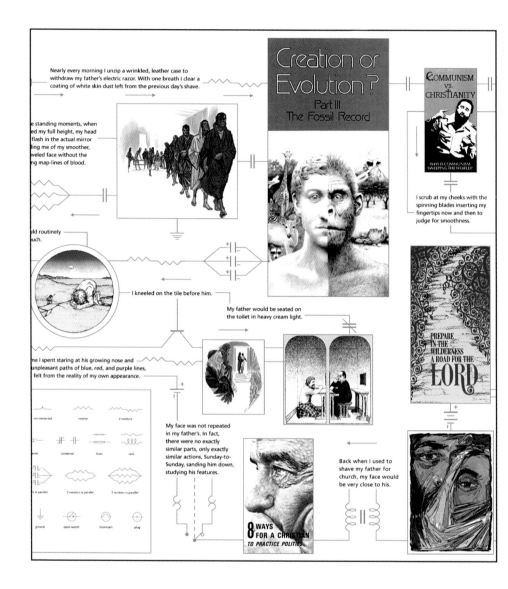

Above: All of the images seen here came from an archive found in a filing cabinet, bought second-hand in Rochester, New York, by photographer Luke Strosnider who was unaware of the hundreds of propaganda items inside. This detail is one of twelve fictional episodes involving a churchgoing father and son. Each part of the story is assembled out of the memory or use of a machine they have in common. Shaw used an organizational system based on the code of electrical circuitry to diagrammatically construct a spatial inter-relationship between the (found) images and his own text. Detail from: Tate Shaw and Andrew Sallee. God Bless This Circuitry. *Rochester, NY: Preacher's Biscuits Books, 2007.*

DIAGRAMMATIC SYSTEMS

Diagrammatic systems are essentially an extension of the array and the assemblage. However, they differ in the sense that image-to-image relationships (or even image-to-text relationships) are further expanded by coded visual structures and devices. In the example to the left, Tate Shaw uses the diagrammatic language of electrical circuitry to suggest complex inter-relationships between the images, his text and the overlap between cognition (or at least a certain kind of programmed thinking), and the machine.

Despite the mechanistic metaphor, Shaw manages to inject the emotional qualities of pathos and loss into his statement. It is worthwhile considering other pre-existing systems that could apply to the organization of work. The Table of the Elements, institutional organizational structures, flow charts and representations of chemical reactions rendered in scientific notation are examples which come immediately to mind.

CONCLUSION

It should be clear that how you structure the experience of viewing your work is an act that is inextricably bound to the issue of clarification of content—in the first instance to yourself, and then subsequently to the viewer. These strategies then imply the need to choose a suitably corresponding form of display. These are examined in the following chapter.

From the author's book, Secrets of the Spread.
Rochester, NY, Clarellen, 2005.

CHAPTER 3
PRESENTATION

INTRODUCTION

Presentation in the first instance should be a logical extension of the nature and form of the work. If, for example, you have decided to create a narrative, or a sequence, then it may make sense to consider placing your work in a time-based forum such as a book or video. If such progressive revelation of content is important to your statement, then simply placing the images in a line on the gallery wall will do little or nothing to enhance this aspect of the work. Conversely, if you feel that it is important to present the viewer with many images simultaneously or if you wish to create the impression of sensory overload, then you will most likely rule out a book and choose to show your work in exhibition or installation form instead.

The presentation should also be appropriate to the content of the imagery. Is the statement you are making gentle, subtle or poetic, or is it grand in scale and scope? Does the work require a site-specific solution, either by exhibiting the images in an appropriate place or alternatively creating a space analogous to that specific or ideal site? How do you want the viewer to feel when he or she looks at your work? Such considerations mean that even within broad choices such as "the book" or "the exhibition," there are many levels of subtlety and refinement. For example, it is possible to produce a very large, highly public book or a very small, intimate exhibition.

Additionally, the presentation should be appropriate to the function that the images are to perform. By this I mean, what are you trying to achieve? At the simplest level, is the work being produced to satisfy course requirements? (There is no point in making a book if a box of matted prints has been

GENERAL CONSIDERATIONS—S C A L E

It is important to consider the appropriate of size of your finished work. Sometimes this is pre-determined. If asked for 8″x10″ prints, then this is what you must produce. Issues of scale in such a case are beyond your ability to control. However, this most commonly occurs in the first year or two of study, and as you proceed it is likely you will have more discretion. However, beware of a process of habituation. Having satisfied such requests for a semester or two, then this scale can insinuate itself into your thinking as a kind of pre-set norm and it is easy to continue to produce and present work in the same way, long after it is necessary.

Additionally, as a painter friend once pointed out, photographers have a tendency to format their work in a very standardized, one-size-fits-all manner. It seemingly takes a very brave photographer to even consider varying the scale of his or her images, especially within a group of work.

Most images have an optimum size. However, determining this is much more art than science. There are no hard and fast rules or simple formulas that will help you to determine the appropriate scale. It is important to look at the work you have produced, not only from the perspective of your original intentions, but also with a critical and more detached eye—almost as if the image were made by someone else. If you can do this, you will find that sometimes it can be apparent that some images are better printed large, while others work better at a smaller, more intimate scale. The best way to decide is to commune quietly with your work, putting your intentions to one side, and see if the prints offer any suggestions on their own.

Finally, it is important to consider the forum in which the work will be viewed and a discussion of the main choices will be next. Suffice it to say that if you want to make a book, then most likely a print size of 30x40 inches will be inappropriate or at best diabolically unwieldy. Similarly, although I have seen exhibitions displaying prints as small as two inches square, as a general rule prints intended for this forum usually work best at a larger scale. Inversely, don't force work into a book if it is best seen from a distance, nor force work into an exhibition if intimacy and tactility are part of its content.

stipulated.) Do you wish to use your work to apply for a job? Is it being made for commercial purposes (and as such are you supplying the client with a commodity)? Are you doing it for completely expressive purposes where you may not want the viewer to respond in any pre-determined manner—or are you trying to communicate a specific cultural, ethical, political (or other) perspective?

All of these expectations, whether determined either by you and your own imperatives, or by an external body such as a school or client, will impact on the form your work will and must take. There is no point for example, printing and overmatting your work so that it is thirty by forty inches in scale if you wish to send it in the mail or carry it around for a job application.

It should be apparent by now that presentation has the potential to affect the very meaning of your photographs. The choice of forum, the concomitant issues of scale of the work, and the order or sequence within which the work is viewed, are all inextricably to how it will be eventually interpreted and/or read. Presentation affords a wonderful opportunity to refine your statement and control how an audience will respond to your visual and artistic concerns.

Below: Not all presentations need be restricted to galleries or other conventional, usually interior spaces. The Rochester based artist Bleu Cease created billboards based on the aphorisms of the 19th century Rochester newspaper publisher, Obadiah Dogberry. The ironic, and somewhat poignant juxtaposition of Cease's work with a pre-existing billboard for a law firm was a serendipitous bonus.

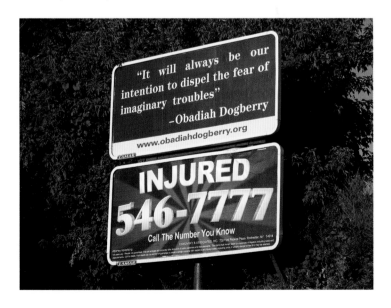

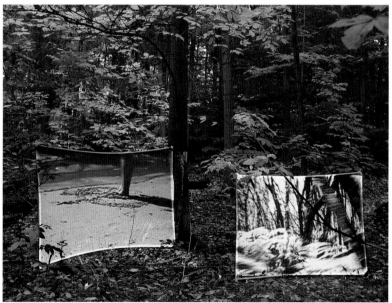

Another example showing how artworks can be presented outside of the usual gallery context. Here Sara Segerlin projected video loops onto gossamer screens placed in the woods. These images show the work at twilight. After dark the atmosphere was even more magical. Additionally, the experience was enhanced by placing speakers in the woods providing ambient sound. Wandering the Land Next to the Sea, *2007.*

THERE ARE SEVEN MAIN WAYS TO PRESENT IMAGES

- The Book
- Portfolios (Simple and/or Hybrid)
- The Exhibition and/or Installation
- Time and/or Screen Based systems

THE BOOK

William Henry Fox Talbot, one of the inventors of photography (his contribution was the Calotype) published the first photobook, *The Pencil of Nature,* only three years after his announcement of his invention. Thus began a relationship between photography and the book that is still vital today.

One of the book's greatest attributes is that it facilitates the making of an extended and coherent statement. The contents of a book are finite and there is a beginning and an end. The length, the content, the amount of text, the number of images, and the visual/spatial relationship between the text and images, are within your control. Thus you can fully explore your subject and achieve a depth of expression which is difficult to match in other forums. Additionally, compared with the constraints of space and time in the exhibition, the book offers a permanent forum where the work can be accessed at any time. The best way to appreciate the opportunities of the book is to simply describe its properties.

- Books manifest the quality of time because the content unfolds progressively.
- The work is presented in a pre-determined sequence.
- A variety of visual concerns may co-exist in the same space.
- It is a warm intimate medium. It can be held in the hand and is truly interactive
- It facilitates image text relationships.

To each in turn...

Books are essentially a time-based medium. The experience of the content is linear, sequential and unfolding. In comparison with viewing work in an exhibition (where usually all of the work can be viewed in a single scan as one enters the room), in a book one looks at images and words sequentially. Thus you can control the nature of the experience by altering the order of the pages so that the reader can be led through the work on a pre-determined path. As each page is turned, the experience of looking at one image is replaced by that of another within the same space. Thus the images (and words if any), and the impression they create, accumulate in the mind of the reader as he or she proceeds through the work.

One of the consequences is that work of great variety can be included within a book in a way that is not possible in an exhibition where there is pressure to edit the work so that it presents a unified visual impression. This can sometimes result in a situation where formal concerns override issues of content, especially if the content is complex. In contrast, the images contained within a book are simultaneously connected but separated from each other. Thus visual concerns can be included that, if seen in immediate juxtaposition, might seem strange, inappropriate or even discordant. It is impossible to stand back and view the contents of a book as a whole. One must engage with the work one page at a time. Direct comparisons and simplified overall views are impossible to

attain. Thus complex, even conflicting ideas can be expressed in their own space, in their own way, yet still be perceived as being part of a greater whole.

Additionally the book has the quality of intimacy—it can be held in one's hands. This tactile connection with the work has the potential to suggest an almost direct link between the author and the reader. The space created implies trust and connection and the act of turning the pages is a subtle yet powerful signifier of intimacy and participation. The book also accommodates to the reader, not the reader to the book. One does not have to read a book at a particular time, in a particular place. It can be read in public on the train or bus or even taken to the bedroom or the bathroom.

Somewhat ironically, in view of its long history, the book is also the fundamental precursor of that most post-modern notion, interactivity. Despite earlier claims about you having the ability to control the sequencing of the work, the reality is that the book can be read from the front, the back, from the middle, and its contents may be either skimmed quickly or digested thoughtfully.

Finally, the book facilitates relationships between words and images. Although there is nothing to stop you having text on the gallery wall, the scale and uniformity of the book's pages facilitates such connections and allows you to communicate more complex ideas. Personal computers have made the production of books easier than ever before, and so this method of presenting your work should be seen as a viable and legitimate alternative particularly as modern programs permit with equal facility the inclusion of text and images.

It is recommended the reader seriously consider this method for the following reasons:

- You maintain control over the means of production and the content.
- It is relatively inexpensive to produce such a book.
- You can print single copies on demand.
- The work so produced may be transferred to other media, e.g. CD ROM.

Digital Book
Design and Publishing

Douglas Holleley

Until the advent of the computer you had only limited choice when it came to making a book. You could either make a completely hand-crafted work or you could be very lucky and have a publisher print the work commercially. Now it is possible to have the best of both worlds. With imaging software such as Adobe Photoshop, and a page layout program like Adobe InDesign or QuarkXPress, you have the same tools that professional publishers use. You can then, relatively easily and inexpensively, print and bind the book yourself by hand or print it on-demand on one of the many sites available online.

Above: Much of this discussion on the book is taken from the author's book Digital Book Design and Publishing, *Rochester, NY: Clarellen, 2001.*

Additionally, because the work, once completed, can be stored on disc, you can easily produce more copies when and if you need them. Unlike conventional printmaking practice where even just setting up the equipment is a long and arduous task, you are not forced by this effort to print the entire edition in one (extended) session. Additionally, documents so produced can be easily written to CD ROM and facilitate the dissemination of your work, quickly and inexpensively.

Even greater choice is now available through the proliferation of do-it-yourself book publisher/printer services. These are readily available via the Internet. A quick search will reveal many choices for producing excellent books. Such books arrive in your mailbox (usually within a week) well-printed and bound, for surprisingly very little expense. I have had great success with Lulu.com, but this is just one of many services now available.

THE PORTFOLIO

Like a book, a portfolio should be an object that you can place on a table and then leave the room, secure in the knowledge that all that the viewer needs to know is enclosed in its (hopefully) well-crafted case. However, all too often what is called a "portfolio" is simply a stack of prints that inhabit the same box. It is essential to appreciate that all of the discipline and attention to detail that occurs in the making of a book such as the need for the inclusion of any contextualizing data (artist statement), the careful labeling of the work, both as a whole, and for each of the individual prints, is systematically addressed.

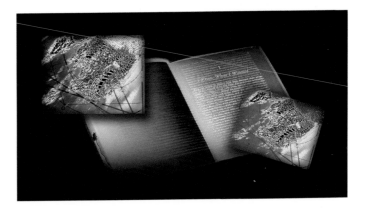

The advantage of a portfolio over either a book or an exhibition is that to a degree you can have your cake and eat it too. Because the images are not physically attached to each other they can either be removed from the box and quickly and easily framed and hung on a wall, or they can be viewed as individual prints. Additionally, the portfolio allows the benefit of constant revision of your work because you can at any time alter the sequence of the prints, remove or add images or make any other changes you feel are necessary.

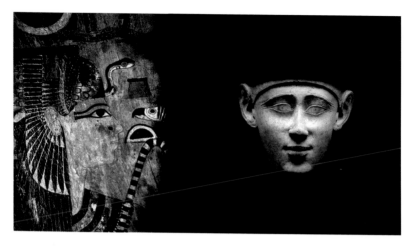

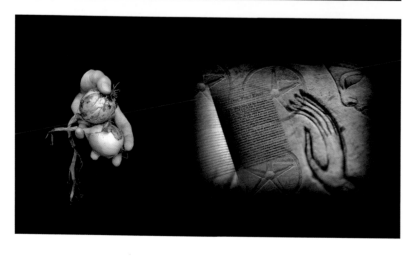

The drawback is the fact that, unlike a book, you cannot lock in a predetermined viewing order if for no other reason than most people seldom put things back the way they were when they have finished reading the work. To a degree you can offset this by simply numbering the prints so that their order is apparent. However, if order is crucial, perhaps you should go with the flow and just make a book or, as the following section discusses, make a serious and determined effort to communicate to the reader the necessity to view the work in a certain order, by structuring the portfolio more along the lines of a book, i.e. by including a Table of Contents and by carefully and clearly numbering the works in a way that links back to the Table of Contents.

Although issues of craft are always important in photography, they seem to be particularly critical in the portfolio form of presentation. This is probably because each element in the portfolio is picked up and handled as it is viewed. Unlike the exhibition, where once the work is framed and you are presented with an almost hermetically sealed fait accompli, or a book where the pages are flexible and constructed to be handled, the viewer is handling something that, generally, you have made out of easily damaged (and often quite cantankerous to work with), materials. As such your craft skills are on full display. If your images are overmatted, expect the viewer to lift up the front board to view the actual print (and how it is attached/mounted to the board) or to turn the mat over and look at the back. If the prints are not matted, then your framing must be precise or at least consistent. Everything will be scrutinized, not necessarily consciously or maliciously, but simply because the viewer is in a position of handling and viewing at close range, original, hand-crafted objects.

In simple terms this means (as a general rule) no horrible yellow masking tape hiding behind nice white mat board, no ball point pen cutting guides, sloppy mat cuts or assembly, and (and this should go without saying) no print defects such as dust spots, fingerprints or damaged, especially dinked, paper.

Previous page and Left: Images from the author's portfolio entitled X. In addition to these images the portfolio also includes a short story and an essay detailing some of the often eerie coincidences that occurred during its development.

Above: A portfolio makes most sense if the images are accompanied by sufficient contextualizing data (either text and/or diagrams) so that the reader is in possession of all he or she needs to make sense of the images. At minimum this means that the title sheet should contain the title of the work, your name and any other data you deem necessary and/or helpful. Here is shown the essay accompanying the author's portfolio, Re-reading the Book. *Rochester, NY: Clarellen, 2000.*

Below: A sample image from the same portfolio showing how Dürer's original black and white images were re-interpreted by introducing color and geometrical shapes.

THE BOOK/PORTFOLIO HYBRID

Above: The Book/portfolio hybrid avoids the problems that can occur when it comes time to exhibit your work in book form—especially if you do not want people to handle the work. Here we have a situation where a book of some 27 images is on display. However, only one double-page spread is visible. In such a case all you can do is quietly mourn the fact that all the other pages remain unseen. This image is of one spread from the author's book, Paper, Scissors and Stone. *Woodford: Rockcorry, 1995.*

A variation on the portfolio or the book is to construct a forum that has some of the qualities of either medium. The term I use to describe this method is the application of the concept of "book think." By this I mean; retain all of the qualities that make the book medium so enticing, such as sequential order, progressive revelation of content, and self-contextualization, but avoid the problems that occur when you then bind the work in a codex. The moment you bind your work, should you subsequently wish to exhibit it, most of the images are hidden from view. (Unless of course you are happy with the audience being able to handle your work.)

Typically in a portfolio the prints are overmatted in cardboard. However, if you present your prints on materials more akin to the pages of a book, then not only can you save money, but produce a very beautiful object.

There are two main aspects to consider. The first is you must devise a system that indicates to the viewer what is the correct order of viewing the work. Unlike a codex (or bound book) a portfolio, if handled carelessly, can get out of sequence. Therefore you must employ some kind of page numbering strategy and ideally prepare an index or table of contents to indicate how the work should be read if it gets out of order. The second issue is how to mount and/or print your images so they do not require overmatting. If you can do this, then each of the elements of the portfolio have the quality of flexible pages rather than stiff unyielding mats. Exercise care when printing so that the print is an object in its own right. Careful framing and well-proportioned margins are the most important considerations.

Mirror and curtain in the foyer of the M & T Ballroom, Cutler Vision.

INTRODUCTION

The Art Museum

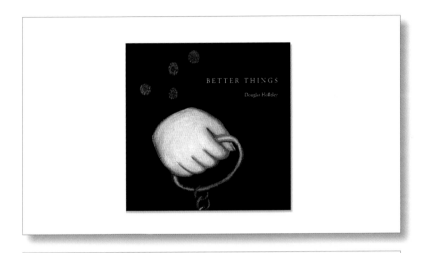

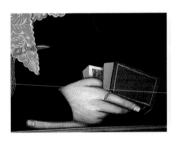 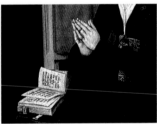

Opposite: Consider each sheet in the portfolio, not as a print, but instead as a double page spread of a book. In this manner you can exercise control over image-text relationships and if you so desire, indicate clearly with page number-ing the sequence in which you would like your im-ages to be viewed. From the introduction to the author's book/portfolio hybrid Better Things. *Rochester, NY: Clarellen, 2004.*

Above: The Title page of the portfolio and a sample of the way the images are paired. This spread is from the first section of the portfolio entitled On Reading. *It contains many images of books: the idea being communicated is that images can be read and interpreted, rather than be simply perceived as precious objects. In the portfolio the images are given numbers to indicate their order. These are handwritten in pencil rather than inkjet printed. Images are details of paintings in the collec-tion of the Memorial Art Gallery of the University of Rochester, NY.*

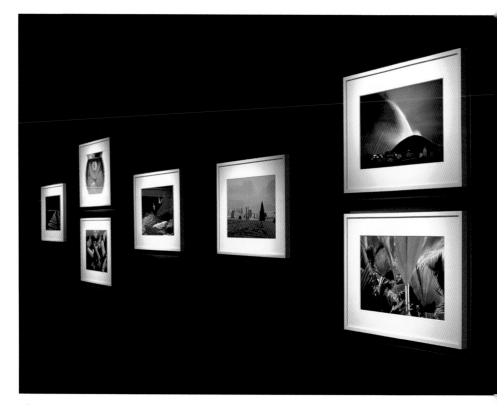

Above: A well-conceived and illuminated exhibition
can truly present a world within a world. In this image
we see the work of Pete Turner on display at George
Eastman House in Rochester, NY. The display is made
particularly attractive by the careful attention Turner
and the Eastman House staff paid to the lighting. In
this case the work is illuminated by lights known as
Framing Projectors. These devices project a precise and
defined rectangle illuminating only the artwork. A good
brand is Solux. (See solux.net) Peter Turner, Empow-
ered by Color, *2006-7. Image courtesy of George*
Eastman House.

THE EXHIBITION

The most characteristic quality of the exhibition is the fact that the work (commonly) is seen in one broad scan of the eyes. Thus the experience of viewing the work is very public. There is no intimacy or unfolding of the process of viewing. All aspects of the show are disclosed simultaneously. This forces certain conventions on the work itself.

In the first instance, it means that because the images are all seen together in one broad view, then the images must somehow be seen as going together. It is very difficult to successfully hang images together that differ too much in scale or content. If this is attempted, then all too often the effect can be fussy or overly busy. At worst the images can begin to actually compete for the viewer's attention rather than complement each other. However, this unifying visual imperative is not necessarily a bad thing. When carefully considered, it invites the viewer to enter the artist's world view in a very convincing way, especially if the images are very large and overwhelm the audience's field of view. If no matter where you stand you are presented with a sense of coherent visual perception, the exhibition can indeed be a world within a world.

Also the exhibition forces you to consider carefully the scale of your work. Do you want the viewer to stand back from the work and receive his or her impressions from a distance, or do you instead want to draw the viewer into your world by making smaller prints that invite or persuade the viewer to approach the images? Such decisions of course will be dictated by the nature of your work, but bear in mind that large prints in a small gallery, or small prints in a large gallery can seem out of place, even grotesque.

This implies that in an ideal world you would not consider having an exhibition until you had some idea of the size and shape of the gallery where the work will eventually end up.

However, seldom do we have this luxury. Nevertheless, it is important to be aware that the exhibition form is in a very real sense a collaboration between the essentially two-dimensional objects that are your photographs and the three dimensional space within which they are housed.

Another important quality of the exhibition is the fact that it is difficult to exercise control over how the work can be viewed in any sort of sequential order. Very few galleries offer the ability to direct the audience through the space in a pre-determined pattern. Thus if you intend to show your work in this forum, you will have to accept the fact that the audience may start at any point within the display. Some folks may start at the place you intended while others will just as likely start from the end or start in the middle and work their way out.

Again this is not necessarily a bad thing. This random access to the content, and the essentially spatial, even theatrical, interaction with your work can provide a rich and satisfying experience for both you and your audience. Additionally awareness of this characteristic can provide many opportunities for creative and individualistic solutions. You

Above: This is an excellent example of image and architectural space working as one. The designer of the exhibition, Rick Hock of George Eastman House, Rochester, NY, paid careful attention to the lighting and the color of the wall(s). Admittedly, not all galleries are either this grand or this willing to allow you to paint them at will. However, carefully consider the space as well as the images themselves. This image is from the exhibition, Lucha Libra, Masked Mexican Wrestlers. *Rosalio Vera Franco,* PONZOÑA (Poisonous), *1991.*

may consider building false walls in the gallery to direct the flow of traffic, or use lighting or other more subtle devices to suggest and imply paths if you feel it important to control the sequential experience of your work. Think of the Tunnel of Love or Ghost Train attractions found in amusement parks (both referred to as "dark rides" in amusement park jargon) and how these attractions structure the experience of moving through a three-dimensional architectural space to permit an ordered, sequential revelation of the images.

In conclusion, be aware that there are also some practical issues to consider if you decide to adopt this method of displaying your work. The most obvious is the fact that galleries are real spaces in the real world and as such are real estate. And real estate is generally expensive, especially in big cities. This means your work is likely to be on display for a relatively short period of time—usually three to four weeks. This period of time can evaporate if you are not organized. Also when you give yourself over to a gallery, institutional, or especially museum setting you may well have to relinquish a certain amount of autonomy to curatorial authority. Additionally, exhibitions require you have significant financial resources. Framing costs, the printing of invitations, the gallery's commission structure, the transport to and from the gallery of framed works and the need to have a place to store any unsold pieces can combine to make exhibitions prohibitively expensive.

Below: Another view of the exhibition, Lucha Libra, Masked Mexican Wrestlers. *Note how the space is organized and the large, translucent screen which permits the projection of a movie. The translucent, screen allows the movie to be viewed on either side of the screen. Installation images by the author, 2007.*

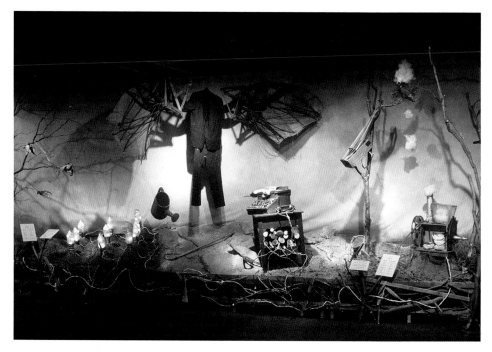

*Above: An installation of artifacts used by Robert and Shana ParkeHarrison
in the making of their images. From the exhibition,* The Architect's Brother,
2002. Image courtesy of George Eastman House.

THE INSTALLATION

A variant of the exhibition form is the installation. It is difficult to draw a concrete distinction between an exhibition and an installation as there are many overlaps. It is probably helpful to think of the difference as being one of degree more than nature. What is usually understood as an installation is the inclusion of elements above and beyond the presence of two-dimensional works hung on a normally illuminated gallery wall.

Such elements can include, but are by no means limited to:

- Selective lighting, including the creative use of darkness.
- The inclusion of three-dimensional sculptural objects.
- The presence of sound and/or music.
- The use of media other than two dimensional still photographs. Thus an installation may utilize video displays, either by themselves or in the company of other more conventionally rendered prints, projected movie films or stills, etc.
- Stimulation of senses other than the eyes (and ears) by introducing odors and touchable surfaces.

Essentially the installation is an attempt to make a more pro-active use of an architectural space. Rather than confine the experience to a detached, essentially horizontally oriented, ocular relationship to the perimeter of the room, the installation aims to involve the audience by providing a more immersive, three-dimensional, multi-sensory experience.

The opportunities for creative solutions are only limited by budget, creativity and the level of tolerance the gallery owner/manager has to idiosyncratic requests (and the terms of his or her public liability insurance). Bear in mind also that the outcome of having such freedom of expression can easily be chaos and/or confusion. Worst of all, if you go too far,

your work can be seen as gimmicky and gauche. A little goes a long way. It is often enough to just carefully consider how you can more creatively illuminate your work. Never forget that photography is literally to write with light. This applies when presenting one's work as well as when photographing. Demonstrating this awareness through careful control over the way your images are illuminated is often enough to transform a stark and mundane experience, to a modulated, sensory and sensual delight.

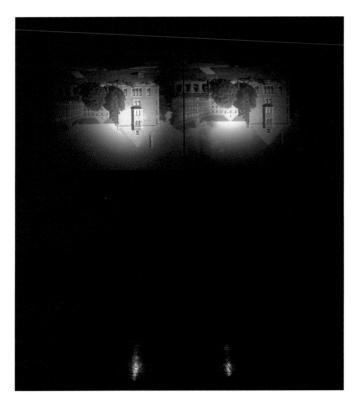

Above: A view of an installation created by Luke Strosnider at the Visual Studies Workshop Gallery in Rochester, NY. Strosnider erected a series of frosted panels in the darkened gallery. Projected onto these panels were views of the outside world via simple convex lenses. Because the panels were displaying images in real time they became a strange hybrid of still photography and movies. For the most part, the images were of static buildings but frequently cars and pedestrians moved across the (upside down) image. What was particularly strange was the sensation that the moving objects were swallowed up by some mysterious force when they would vanish into the gap between the two panels.

Above: This sculpture was first conceived and photographed in Ithaca, NY, in 1997. As such it existed for only two days before disappearing into boxes in my basement. A few years later, it was reconstructed for an installation and exhibition of the author's artist's books. This time it survived for a month. Again, it disappeared into boxes and ultimately these ended up at the Salvation Army Store. Bearing in mind that the one thing we can always count on in life is perversity, this action subsequently prompted a request to rebuild it in a more permanent form in the Wallace Library of the Rochester Institute of Technology. After a search for another 440 books this was accomplished. Image and sculpture by the author, The Monument to Ephemeral Facts, *1997-2007.*

Left: These are more images from Lisa Dahl's movie(s). Seen in a time-based sequence they modulate and merge to create a poignant sense of personal loss and change.

Should you try this method, remember you are essentially changing both media and roles—from still photographer to movie director. Therefore do not expect immediate gratification. Try it with the expectation that it will require refinement. Additionally you will have to acquire some skill in sound editing. This is not the sort of presentation you leave until the last minute!

TIME AND SCREEN BASED SYSTEMS FOR STILL IMAGES

Above: This image, and those on the opposite page are made by Lisa Dahl for the Accumulation Project. (See accumulationproject. org) The project involved a number of artists selecting and categorizing a variety of curious, often whimsical objects. Dahl chose to pho- tograph mattresses discarded by Manhattanites. More to the point, she then placed these images in short, elegant movies each time she ac- cumulated a set of pictures. Additionally Dahl published these images in book form. See LisaDahlStudio. com/DiscardedDreams.

Often overlooked, but often highly successful, is the technique of filming or videorecording of still images. This form of presentation is often very useful if your images are either narrative or sequential in nature. Technically it is a simple procedure and either involves setting up a video camera on a copy stand and simply photographing the images in the desired sequence or using a program such as Adobe Premier (Pro or Elements) or Apple Final Cut (Pro or Express) or iMovie to sequence digital files.

Should you attempt the first method, consider the fact that a video camera can participate actively in how the still images are rendered. I remember one student in Australia who broke all the rules of copy photography and illuminated his still images with a combination of tungsten, fluorescent and occasional daylight, normally an unforgivable act. However, in this case these combined light sources caused the straight black and white images to glow and modulate in a particularly beautiful, even breathtaking way. The opportunity also exists to introduce objects, both in their own right and in combination/collage with the flat photographs, as well as introducing shadows, points of light etc. from off camera.

Perhaps the greatest advantage of this form is that it is relatively easy to introduce sound as an active component of your work. Although there was mention of sound in the context of the installation, it has to be admitted that sound in a static three-dimensional display, unless it is highly abstract, almost background noise, is less successful than when it accompanies a movie-like experience. I suspect that this is because that music, like a movie, is essentially a time-based linear medium. However, in a movie (and that is what your work becomes when you present it this way), sound can permit you to shape audience response and inject mystery and emotion in an almost uncanny manner.

ELECTRONIC DELIVERY SYSTEMS

Electronic systems tend to be either web-based or archived on CD ROM. You can choose to use either system as a different way of communicating pre-determined, sequential content (for example making a pdf file of a book or image sequence) or you can use them to take advantage of the more open-ended solutions that are permitted by hyper-linking to places outside your document, either by using text links or clickable hot spots.

Probably the single greatest advantage of this form of presentation from a student's perspective is its low cost of manufacture, especially when you consider the large amount of information that can be stored and displayed. One need only possess the cheapest digital camera and access to a computer to construct work that will display brilliantly on the computer screen and occupy the viewer for hours if you should so desire.

The images on this spread and on the following page are the work of the highly prolific Jason Nelson. Although born in the United States, Jason now lives and works on the Gold Coast of Australia. In these images (actually screen grabs from his website secrettechnology.com) Jason uses the organizational strategy of games to get his message across.

In the game the viewer (player) moves through a series of levels while being bombarded with image, text and sound.

More interestingly, you have the potential to create new connections between your images and easily combine these images with text or other graphic solutions. However, be aware that web-based content cannot be protected or sold in the same way as a tangible object such as a print or even a CD ROM. Thus, if commercial considerations are part of your long term vocational plans, be mindful of this drawback. However, websites can form a complement to more traditional forms of image dissemination such as books, so in the long run you may be able to have it both ways, assuming that you modify your content with respect to the properties of these two quite different forms of delivery.

CONTEXTUALIZING YOUR DATA

Regardless of the forum, there is one fundamental issue that you must address. No matter what solution you employ, it is essential that you provide the audience with all the information that it requires to understand your work. Ideally the work should be a self-contained entity. It should not require that you be there to identify yourself or to explain or amplify anything.

At the simplest level this means that any presentation must (as a general rule) contain the following basic elements:

1. Your name.
2. A Title that refers to the work (not the course) for which it was produced.
3. The Date.
4. Any pertinent technical details.
5. Any pertinent conceptual details. (Usually referred to as an artist's statement.)

The best way to think of this is to imagine what you would want or need to say to your audience if you handed them a book or portfolio of your work, or if they walked into a gallery space where your work was on show. What would you feel these people would have to know? What would you like them to know?

At minimum they would probably want to know your name! They most likely would also like a title to identify the work, either as a whole, or as individual pieces. However, there are probably many things you would want to say to help these people to locate themselves with respect to the work. The means for doing this is the Artist's Statement.

WRITING AN ARTIST STATEMENT

Because of the sheer variety of imaging methods and schools of thought in contemporary photographic practice, it is only right and proper that you intelligently discuss the content and scope of your imagery so others can "locate" this work within the field.

Sometimes this statement is referred to as a "Statement of Intention." This is extremely problematic terminology as it implies that it is necessary to make the case that what you have done, is exactly what you intended to do and, as discussed in the essay *Intention vs. Effect* (see page 13), seldom does this occur. To say it another way, a statement of intention is forward looking while an Artist Statement is a self-evaluation of your work as it stands in the here and now. If anything, it is looking back at the process and the work and evaluating your progress, effort and results. More than anything it implies that you understand what you have done.

The task is to "read" your own work, within the context of your intentions, yet be able to simultaneously separate these intentions from the work should it have evolved or even gone off on a completely unanticipated tangent. The more time and thought you give to this process, the more helpful it will be to you and the more satisfying it will be to the audience.

In the first instance consider your intentions. If you had clear objectives before starting the work, ask yourself,

- In what way have I realized these intentions?
- Where have they varied them in response to other issues that emerged as the work progressed?
- Are they still relevant? (In response you might find them to be either partially, fully or simply a starting point.)
- What is the work actually saying now that it is finished?

When you have finished, then refer to other artists working in a similar vein and/or quote writers and theorists who have canvassed the issues you have chosen to explore. This is not difficult and goes a long way to enable others to share both your view of the world and the means you have adopted to communicate it. Sometimes if you possess a distrust of theoretical analysis you may be tempted to say, "the pictures need no explanation." Certainly on very rare occasions this can be the case. However, be aware that this claim is also is a theoretical position, rooted in the modernistic argument that the evidence of the photograph is self-explanatory and needs no contextualizing information.

Finally, wherever possible avoid the temptation to adopt arcane language (sometimes known as "artspeak") in order to imbue the work with gravity and authority. Such attempts almost always fail in comparison with a position of candor and honesty. In much the same way one's photographs are always more honest, direct and (usually) successful when you work within your sense of self and with subject matter you know and even love, so too will your statement be more successful if you use your own words, in your own way. This is not however, a license to be unaware of the field and the work of theoreticians and practitioners whose thoughts and images either dovetail with, or overlap, your work. There is a fine line between deep inner personal conviction expressed in a taciturn manner, and naiveté.

CONCLUSION

The point I am making is your presentation, should any or all of these issues be important to you, should incorporate these issues as an integral part of the final work. Anything less is at best suspense, at worst an incomplete hodgepodge.

Having considered this you may wish to subvert these conventions. Some artists (e.g. Anne Hamilton and Stelarc) often choose to be physically part of the exhibition and engage in performance activities in person, forming part of the content. You may wish the work to be anonymous and mysterious, seemingly generated by itself. You may wish to minimize the importance of the technique. Irrespective of what you decide it is important to remember that each decision to disclose or withhold information will be part of the communicated content of the work. Remember, you are always saying something either by accident or design.

Jason Nelson's game eventually ends on this page. It is worth the effort to persist. Once you get to the end, you will be rewarded by viewing even more of his work. See secrettechnology.com/gamegame/gamegame.html

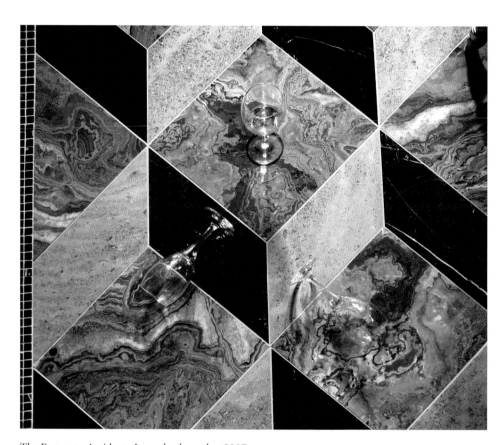

The Fortunate Accident. *Image by the author 2007.*

CHAPTER 4
PRESENTATION TECHNIQUES

IMPORTANT SAFETY NOTE

All of the techniques described in this chapter use sharp tools that can cause serious bodily injury. The reader is cautioned to use great care when following the instructions. Be sure to read all directions that come with any tools you purchase. Also, be sure you are using a sharp knife—dull blades, somewhat counter-intuitively, are far more dangerous as you need to use extra effort rather than let the tool do the job. Eye protection is also advised. Working in a clean, well-illuminated and uncluttered environment also minimizes risk. Above all, be patient and be careful. The author and publisher accept no responsibility for accidents that might occur, especially those due to last-minute rush, carelessness or fatigue—probably the most common causes of injury and accident.

INTRODUCTION

In this chapter, a variety of methods for presenting work will be discussed and explained. All of the following methods are within the ability of any careful and patient person, and all will help make your work both more beautiful and more accessible to your audience.

The following presentation skills will be explained in a practical and useful manner:

- Making a simple Concertina book.
- Working with Cloth and Board.
 A Two-Piece Hard Cover for a Concertina Book.
 Making a Two-piece Portfolio Box.
- Matting Prints.
- Print as Object.

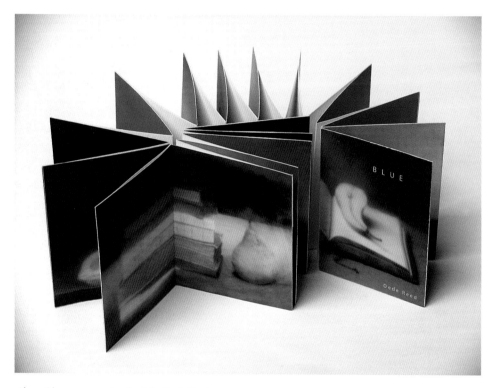

Above: Blue, *a concertina book by Dede Reed,*
made at the Maine Media Workshops, 2007.

MAKING A SIMPLE CONCERTINA BOOK

If you are new to book-making, you may wish to consider starting by constructing a concertina book. However, be warned that although simple, such books are not necessarily easy. As with any craft, you will need to exercise patience and gain skill. Little things, even as simple as cutting your prints/ pages accurately, can make the all the difference in the quality of the finished object.

The advantage of this process is that this form of binding is equally suitable for making quick, relatively small books as you progress, as well as for making quite beautiful and finished objects when you come to present your final work. They can be any scale, anything from 2–3 inches square (5–7cm) and up.

Additionally, this form permits you to read your work as a linear sequence, or you can unfold the concertina and display your work in such a way that all the contents are visible in one glance—almost a kind of mini-exhibition. The following instructions should help you to get started. In this case we will use the concertina structure to bind a simple proof sheet that was printed directly from Photoshop. In so doing, the prosaic proof sheet suddenly transforms from an intermediate stage in the photographic process to a finished object of beauty and integrity.

What is particularly helpful about this method is that each single image automatically becomes a double-page spread. This reinforces the most helpful concept to keep in mind when making any book—that is, consider the way your images work together as a spread, rather than one page at a time. Although programs like Adobe InDesign are called page layout programs, it is infinitely more desirable to think of them as spread layout programs. This small shift in thinking produces results far in excess of what you might expect.

1. You will need the following items: Your prints, a cutting mat, a steel rule, sharp knife, a bone folder, one or two large bulldog paper clips and some 3M brand, mylar-based, paper-backed, double sided tape. It is worth the effort to get this particular product. It is archivally sound, very narrow (you can get it a quarter of an inch wide) and the paper backing makes it relatively easy to position and work with. It can be ordered from any good library supply company such as Gaylord.com.

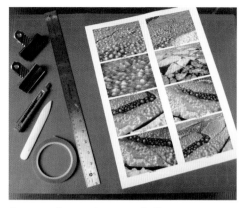

Prepare a clean work space and collect your raw materials and tools.

2. In this case we are making a small book from prints cut from a Photoshop proof sheet. However, the same procedures also apply to larger documents produced in InDesign. If the latter is the case, then select the spreads option when you print so that each sheet ends up with two facing pages printed side by side. Ideally, print across the short side of the sheet as most, if not all papers have the grain parallel to the long side. Folding across the grain sometimes cannot be avoided—but it is best if you can have the sheet oriented so that when the book is finished, the grain is parallel to the spine. Fold the prints in half to produce the spread. Burnish the fold with your folder.

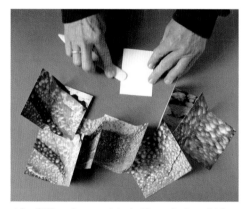

After folding the spreads in half, use the bone folder to burnish the fold.

3. Ensure your pages are in correct order and all correctly oriented so that none are unintentionally upside down. Then carefully square them up to form the book block. Use the bulldog clip(s) to clamp the folded edges securely in position. After taping the spreads together these will become the spine.

Clamp at the folded edge with a bulldog clip.

Be careful when using the double sided tape. It sticks fiercely and irreversibly on contact.

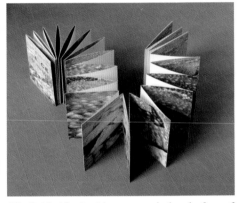

The finished book with cover attached to the front of the block. The author's book I CE, *op cit.*

4. Use the tape to join the spreads together at the outside edges of each page. This can be quite fiddly and patience and care at this stage pays big dividends. Put the tape in place on one page and carefully hold back the other sheet while you peel the protective paper backing from the tape. You may find it helpful to place a spacer (an eraser is excellent) between the pages being taped to give you some working room. Do not accidentally tape the inside of the spreads together. Be sure you apply the tape to the rear of the sheets.

5. When you have finished, the book will look something like the image to the left. You will see that you can arrange it in any number of configurations. You may however, prefer to have it more closely resemble, and be able to be read like, a regular book. If this is the case, then tape the rear of the pages together where the folds meet at the spine. There is no need to clamp the book as the pages are safely taped in position at the edges.

The final step is to make a cover for your book. The simplest way to do this is to select one of the internal pages, place a title and your name on the right hand side of the image and cut the print in two.

You will now have two separate pages, each being half of one print (or spread). Tape the right hand side with the title on the front of the book, similarly attach the left hand side of the image to the back of the book. Use two pieces of tape, one on the outside edge, the other on the spine edge, adjacent and parallel to, the fold.

ON DEMAND PUBLISHING OPTIONS

If hand-crafting a book is not to your liking, then consider using one of the many "on-demand" websites that allow you within days to receive a beautifully printed and bound book. These services are nothing short of miraculous. They all work on much the same principle. You collect your files and then upload them to site of your choice.

NOTE:
This is only a very small selection out of a huge range of services. For more choices use Google to search for on-demand printing and take your pick.

You can use these sites in a number of ways. The most obvious of course is to carefully craft and sequence your images, write a suitable accompanying text, and produce a highly "finished" book. However, you can also use them to review your work as you progress. By this I mean, rather than make a proof sheet, why not simply upload your images in the sequence they were photographed, and in this way allow your total response to be printed and subsequently evaluated as a whole.

Certainly one of the biggest tricks of digital photography is keeping track of all your data. It is very easy to let it get out of control. To this end, rather than accumulate proof sheets or deal with eternally inflating folders of stuff on your computer, why not print as you go? At around fifteen cents a page you can keep track of your work and have the gratification of seeing it accumulate in an organized and easily accessible manner.

All of these sites use high-speed digital presses of one form or other. Where they differ is in how you prepare your files. Some sites ask you to upload image files that are then positioned on a page while others use various kinds of software to construct a document that is then uploaded. The choice depends on how much control you wish to exercise. The following is a brief summary of the characteristics of three such sites.

Lulu.com

Lulu approaches the design/upload issue in two ways. Like Blurb, Lulu offers what they call a Photobook option. Rather than using downloadable software, Lulu simply asks you to upload files and place them in position in various templates. However, more fun, and more challenging is to select a paperback or hardbound

book option, and create an InDesign file to suit.

I particularly like this option as it is a great incentive to get practice in using this software. As InDesign enjoys considerable (publishing) industry support it is good for your professional development to feel comfortable within its workspace. It is another notch on your skill acquisition belt. When you have completed your document, you convert the file to a pdf using the "High Quality Print" pre-sets, upload the file and that's it.

• Pros: If you choose the pdf option you will gain practice in using a professional program.

• Cons: The learning curve is steeper than for the Booksmart software of Blurb.

BLURB.COM

Blurb specializes in the making of photography books. To this end they have developed proprietary software called Booksmart. This software is free. You download it to your machine and follow the simple directions. To make things easy, Blurb gives you a variety of templates which you can use as is, or modify to suit your work.

• Pros: Easy, very good quality and particularly attuned to a photographer's needs.

• Cons: The software is particular to the site and is not the kind of software you will use in professional practice if you wish graphic design to be part of your range of skills. However, they do provide a workaround if you would like to use a program like Adobe's InDesign which permits these files to be opened and printed via the Booksmart software.

SHAREDINK.COM

SharedInk is very similar to Blurb and the Photobook option in Lulu. It offers a variety of templates and individual files are uploaded either one at a time or in a "zipped" folder.

• Pros: Very good print quality and very nice paper. The books have an inviting handcrafted feel.

• Cons: Will not accept pdf page layout files.

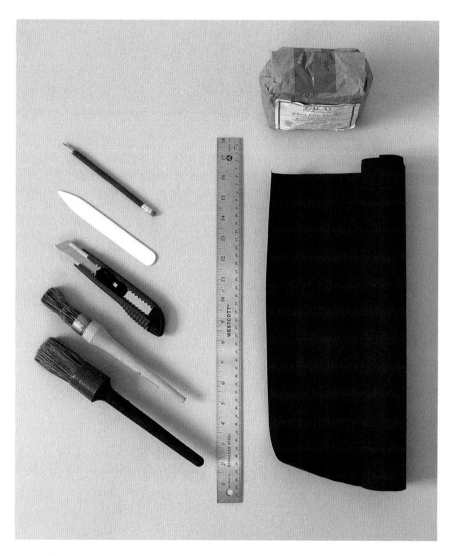

Above: These are the tools you will need. From the red pencil, in a counter clock-wise direction we see a bone folder, a sharp knife, one or two brushes to apply the paste, a metal ruler for marking out and cutting, some bookcloth and some paste. (Also needed is white Elmer's Glue-All.) You will also need box board. In this pho-tograph, the box board forms the background. It is a good idea to also purchase a spare sheet or two to act as a cutting board.

WORKING WITH CLOTH AND BOARD

If presenting your work in book form or as a portfolio, you will need a basic understanding of bookmaking techniques. In a nutshell this means being comfortable with working with bookcloth and boxboard. I have addressed this subject in great detail in my book *Digital Book Design and Publishing*. However, I have simplified some of this material for this chapter so you may begin immediately if either of these two presentation forms seem appropriate.

In the first instance we will discuss the tools and materials you will need to proceed. Following this there will be instructions for making a simple two-piece cover for a concertina book, and a two-piece portfolio box. Both of these are very simple if you are careful and patient.

BOOKBINDING TOOLS AND MATERIALS

You will need:

1. A bone folder. This piece of equipment is essential. It is used to burnish edges and coax pasted paper and cloth into position.

2. A sharp knife. Get a Stanley type knife, or a knife with scored snap-off blades. Either ensures you are always working with a sharp edge. More errors, poor results and accidents are caused by using blunt knives than for perhaps any other reason.

3. A brush to apply your paste. A bookbinding supply house can supply you with a wide choice of brushes specifically designed for bookbinding work. A good substitute is a sash brush obtainable from a hardware store.

4. A metal ruler for marking out and cutting the board and cloth. You may also consider buying a heavy metal straight edge to more safely cut heavy board.

5. Bookcloth to cover the boards. A good supplier is Talas in New York, NY (talasonline.com). A good stock to start with is a cloth such as Canapetta natural. It is very forgiving of errors.

6. Boxboard, ideally acid free, to make your cover or box. It is good practice to buy an extra sheet or two to act as a cutting board. Davey Red Label Board from Talas is a good choice.

7. Paste and Glue. Because for the most part we are joining large surfaces, it is best to use a slow-drying paste so that the adhesive stays wet while you work. On the previous page the photograph shows some "Instant Wheat Paste No. 301" obtainable from Talas. This comes as a powder which you add to water. Also needed is Elmer's glue (white). This is for small construction details like attaching the finished cover to the book or attaching boards together. Elmer's can be used in an emergency to attach the cloth but it will need to be diluted about 50/50 with water or it will dry too fast and not cover the whole surface evenly.

Additionally it is helpful to have:

• Old newspapers which you will use to protect your work space when applying paste or glue to the various components.

• A damp rag to wipe off any excess paste and to keep your hands clean while you work.

• Something to weight your work while it dries. An excellent solution is to use thick laminated composition woodchip board, like the material used to make kitchen cupboards. The heavier and thicker, the better. You should have two boards, one to provide a firm base and the other to be placed on top of the project. You can old books or bricks if you need extra weight.

A TWO-PIECE HARD COVER FOR
A CONCERTINA BOOK

If you have made a concertina book, you may wish to both protect its contents and give it more weight by binding it with a hard cover. The easiest way to do this is to make two separate cloth-covered boards which are attached to the front and rear of the book block.

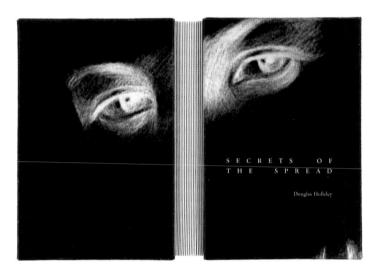

Above: The concertina book can also be bound with hard boards rather than paper. In this case the boards have been covered with a canvas designed to accept inkjet printing. All the same the surface is very fragile and sometimes scuffing can occur during the binding process. However, this can be repaired by spraying the boards, after they have thoroughly dried, with a protective coating. The author's book, Secrets of the Spread, *Rochester, NY: Clarellen, 2005.*

To make the hard cover, cut two pieces of cardboard to form the core of the cover. These will then be covered with bookcloth.

• The grain of the board must run from north to south.
• The size of the boards must be slightly larger than the bound contents to form a protective lip. The amount of this overlap is 0.125″ (3 mm) on the top, the outside edge and the bottom. At the spine the board will be flush with the contents. Thus if you are binding a vertical US Letter size book you will cut two boards each 8.625″ wide and 11.25″ high. (For an A4 book the boards will be 213mm by 303mm.)

Place these down on the bookcloth on a cutting board as shown in the diagram below. Measure a one inch overlap (25mm) around the cover boards. Mark out the corners (as indicated in red) so that the line at 45° to the board is the thickness of the cover boards plus a sixteenth of an inch (1–2mm) away from the corner(s) of the boards. (Do not cut them just yet.)

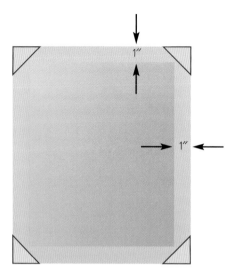

1. Cut the bookcloth one inch around the border of the boards. DO NOT cut the corners off the bookcloth yet.

2. Place some scrap paper under your bookcloth and apply the paste to the bookcloth. It is good practice to also apply paste to the board which can be very thirsty. Immediately dispose of the scrap paper to keep your work clean.

3. Place the cover board in position. Burnish the board down with your folder to ensure it is firmly attached to the cloth.

4. Cut the corners of the bookcloth at 45°, leaving around an eighth of an inch (3–4mm) between the cut corner and the corner of the cover board. The correct amount is the thickness of the board plus a "tad."

Apply paste to both the bookcloth and the boards and then lay the boards in position on the cloth.

Trim the cloth corners so they are a little more than the thickness of the board (usually 0.125″ or 4mm) away from the corners of the board. (See detail view below.)

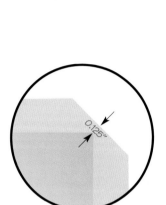

5. Begin wrapping the bookcloth over the cover boards. Start at the top first. Pull the pasted cloth up towards you and then round it over the top of the cover board. Repeat this step on the bottom. Use your folder to burnish the cloth so it is firmly adhered to the board. You will find that the cloth, when wet, stretches quite easily and can be worked into shape.

Begin folding the bookcloth over the boards, starting from the top. Burnish the cloth onto the board. Next fold the bottom flap.

A small triangle of double thickness bookcloth will be formed at the corners when the flap is folded. (See overleaf.)

Now fold either side. Ensure the corner of the board is fully covered with cloth by pushing down the small triangle before folding over the remaining flaps. (See the magnified view of the corner below.)

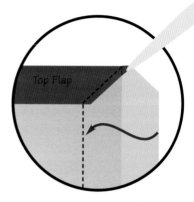

Top Flap

6. Now work on the flaps at either side. You will notice at each of the corners where you have turned over the cloth, that a little triangle of doubled over bookcloth is formed. You must pinch this down with your folder so the triangle is firmly adhered to the back of the bookcloth. This will ensure that the bookcloth completely covers the cardboard at the corner. You will find that the wet cloth is quite malleable and can be easily worked into position.

7. Place your heavy boards (or a number of old books) on it and press it firmly. Allow it to dry overnight under weight. Then you are ready to attach the inside of the book to the cover.

8. Using Elmer's glue, attach each board in turn to the front and rear of the book. Observe in the diagram opposite how the cover overlaps the top, bottom and outside edge, but remains flush with the spine. Weight the book with your boards and allow it to dry.

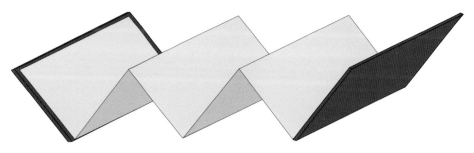

Using Elmer's glue, attach each board in turn to the front and rear of the book. Observe in the diagram above how the cover overlaps the top, bottom and outside edge, but remains flush with the spine.

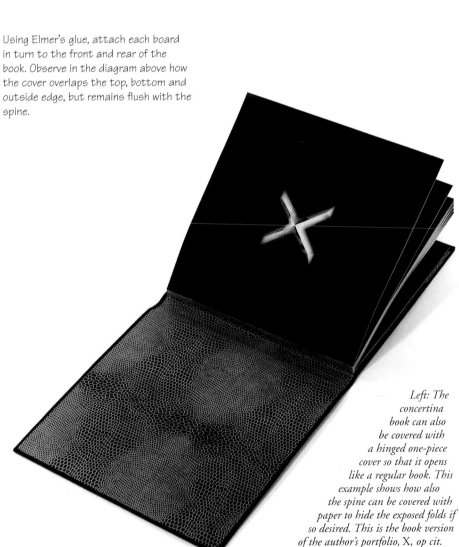

Left: The concertina book can also be covered with a hinged one-piece cover so that it opens like a regular book. This example shows how also the spine can be covered with paper to hide the exposed folds if so desired. This is the book version of the author's portfolio, X, op cit.

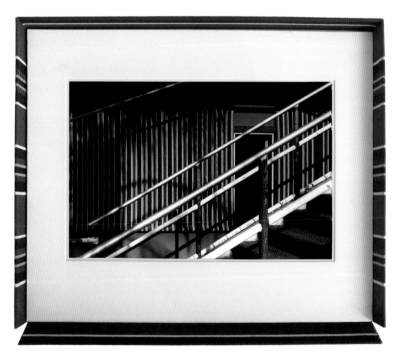

MAKING A TWO-PIECE PORTFOLIO BOX

Should you decide to present your work either as a portfolio or as a book/portfolio hybrid, you will need a box to store your finished prints. Very handsome boxes can be purchased from a supplier such as LightImpressions.com and quite beautiful boxes (made to order) can be purchased from Portfolio Box Inc., RI.

However, nothing quite compares to the satisfaction that comes from making a box from scratch. In this section we will construct a two-piece portfolio box. These are simplest boxes to make but they do require some skill and a lot of patience, especially if you have not made one before. Although the process at first glance may look a little intimidating, it has been my experience that most folk get a very serviceable object on their first try, a quite good object on their second and an excellent object the third time around. The beauty of making a box oneself is that one can choose materials and colors that exactly suit the contents.

In the first instance you must decide what size your box will be. There is a very handy rule which makes this easy. This is the three eighth/three quarter rule. (In metric the one/two rule.) In other words what ever size paper or board you are going to house add three eighths of an inch (1cm) to each dimension to determine the size of the base, and three quarters of an inch (2cm) to determine the size of the lid. This works no matter what your initial size is—be it as tiny as 2x3 inch (50x75mm) or as big as 20x24 inches (50x60cms). For the purposes of example we are going to show the layout of a box for Super B paper. This paper is 13x19 inches (330x483mm). Thus the base will be 13.375x19.375 inches (340x493mm) and the lid will be 13.75x19.75 inches (350x503mm). Again for purposes of example we are going to assume the box will be 1 inch (25mm) deep at the base. Therefore to clear this base the lid will be 1.125 inches (28mm) deep. (This value is obtained by adding the height of the base to one thickness of board—usually 0.125″ or 3mm.)

Opposite: To make a portfolio box for a set of images of an amusement park, I selected the same kind of material that was pictured in many of the images. From the author's portfolio, The Last Day of Luna Park, *1981.*

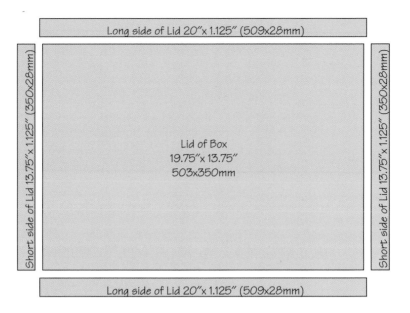

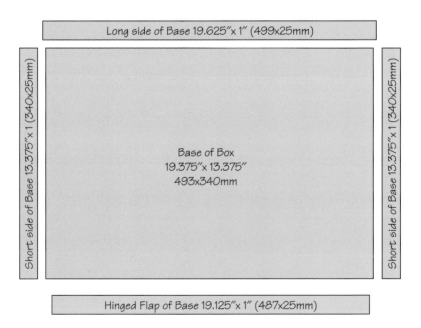

When cutting the board, align the grain so that it is parallel to the longest dimension.

Start by laying out the measurements on the box board as shown opposite. Note that the dimensions of the two longer sides of the lid are greater than the lid itself. This is because they will overlap the shorter sides at the corners to form a neat, square joint. The amount of overlap is determined by the thickness of the board at each end. Assuming the board is 0.125″ (3mm) thick, the longer sides will each be 0.25″ (6mm) greater than the lid or base.

The base however, has only one side longer. This is because the hinged flap must fit in between the two short sides.

To begin construction, attach the side pieces to the base and the lid. Do not glue the hinged flap of the base—this will be attached later. The boards are attached by simply butt gluing them together with Elmer's Glue. You will be surprised how strong this is when it dries. However this gluing is not what gives the box its full strength. When we finish this stage, the entire assembly, inside and out, is going to be covered with book cloth. When this layer is applied the box will assume extra strength from this cloth skin.

Construct the lid first. Place the largest board on a piece of newsprint. Apply a thin bead of glue to one of the shorter side boards and attach it to the base as shown below.

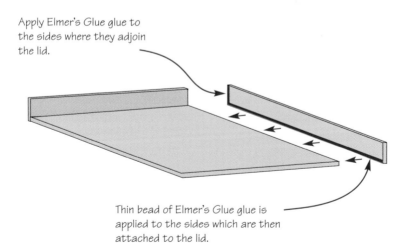

Apply Elmer's Glue glue to the sides where they adjoin the lid.

Thin bead of Elmer's Glue glue is applied to the sides which are then attached to the lid.

Attach the other three sides in turn. You will see that the two longer sides are longer than the lid by the thickness of two pieces of cardboard. Glue them to the adjacent sides as well as the base.

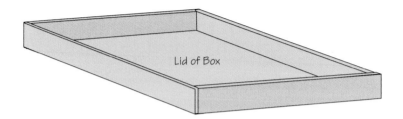

Lid of Box

Now proceed to the base of the box and repeat this operation. When you have finished you will have the lid with all sides attached (as above) and the base will have only three sides attached. (See below.) The flap will be attached later.

Left: When the lid of the box is assembled it will look like this. You may find it necessary to brace the cardboard as it dries with old books, or bricks covered with paper or cloth. Ensure all the corners are joined and the box is square.

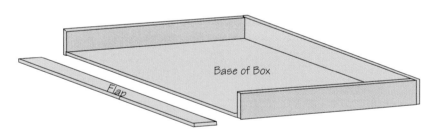

Base of Box

Flap

Left: When the base of the box is assembled it will look like this. Do not attach the hinged flap at this stage.

Brace the box with bricks or heavy old books while the glue dries. You may prefer to allow the butt joints to dry overnight. This way you will be covering a structure that is completely dry and rigid. This makes the task considerably easier. Additionally, after the joints have dried completely, you can sand the box with abrasive paper to remove any excess glue or other inconsistencies.

You will next need to mark out the bookcloth. The accompanying diagram will help you to do this. We will cover the entire structure with cloth, inside and out. The corners will require some care so as to completely hide the cardboard.

Lay the bookcloth face down on a clean surface. Place the assembled lid of the box on the bookcloth as shown below. It is helpful to weight the box while you do this so that it does not shift position. Mark the position of the box on the cloth by tracing around it with a pencil. Then mark and cut out the cloth as shown below. You have to leave sufficient material to cover the sides outside and in and then have enough left over to paste it to the (inside) bottom of the lid. A simple formula is to allow two and a half to three times the height of the box.

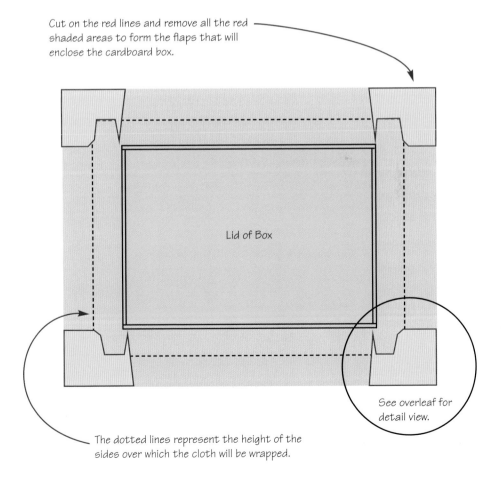

Cut on the red lines and remove all the red shaded areas to form the flaps that will enclose the cardboard box.

Lid of Box

See overleaf for detail view.

The dotted lines represent the height of the sides over which the cloth will be wrapped.

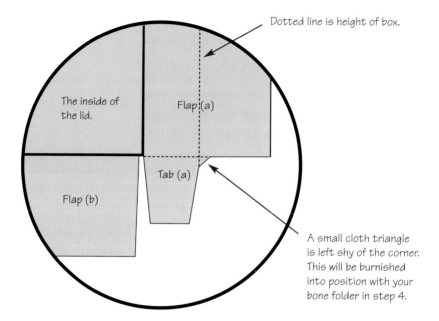

Dotted line is height of box.

The inside of the lid.

Flap (a)

Tab (a)

Flap (b)

A small cloth triangle is left shy of the corner. This will be burnished into position with your bone folder in step 4.

Covering the Lid, Step by Step

The biggest aid to success is having a large, unimpeded space to work and plenty of scrap newspaper which you will place under the cloth while the paste is applied. Take the time to properly clear your work table. It is also advisable to have a good supply of paper towels and a clean, damp rag to wipe any excess paste from the bookcloth if you get some in the wrong place.

1. Start with the lid. Lay it on the cloth and align it to your pencil marks. Make sure all is OK and then remove it and apply paste to the entire cloth. (Discard the newspaper and keep your work space clean.) Now place the lid on the cloth after first also applying paste to the board. Burnish to adhere the board to the cloth.

2. To cover the sides pull Flap (a) and attach it to the outside only of the side. (See opposite page.) Burnish it to the board with your bone folder. Leave the flap that will eventually cover the inside hanging loosely inside the box at this stage.

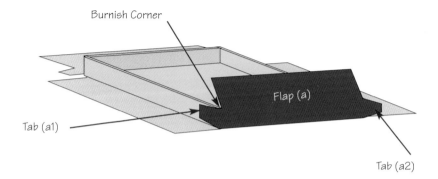

3. Wrap Tab (a1) around the adjacent side (as above).

4. The little triangle of cloth that remains can now be wrapped over the top of the corner and burnished into position.

5. Next wrap Tab (a2) around the opposite side—again burnishing the small triangle into position, ensuring the cardboard at the corner is completely covered. Use your bone folder to stretch and pull the tab into position.

6. The remaining material of Flap (a) that was hanging loosely inside the box should now be burnished firmly to the inside of the side of the box and to the inside of the base. Work the cloth carefully into the inside corner joints.

7. Repeat for the opposite side of the lid.

8. Now wrap each Flap (b) over each long side to cover the box. (See below.) Burnish all interior corners thoroughly.

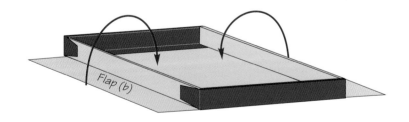

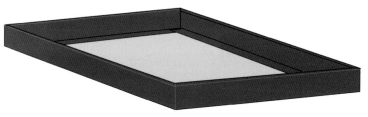

Left: The finished lid .

COVERING THE BASE, STEP BY STEP.

This operation is very similar to covering the lid—the only difference being that we must now attach the hinged flap. If we were not to do this it would be very difficult to remove the prints from the box. Mark out your bookcloth as shown below.

Cut on the red lines and remove all the red shaded areas to form the flaps that will enclose the cardboard box.

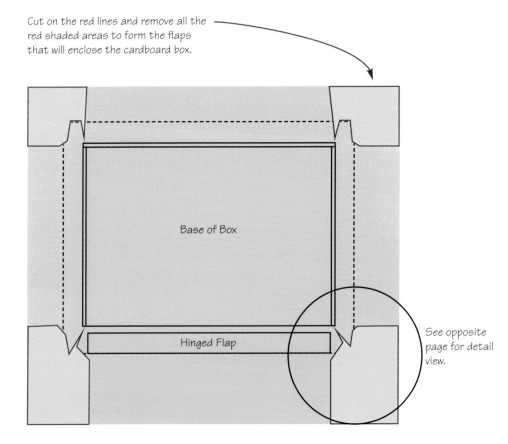

Base of Box

Hinged Flap

See opposite page for detail view.

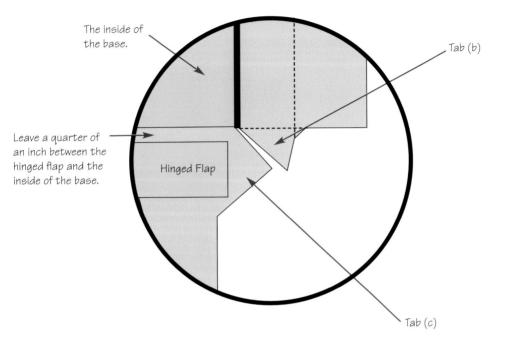

The inside of the base.

Tab (b)

Leave a quarter of an inch between the hinged flap and the inside of the base.

Hinged Flap

Tab (c)

Examine the drawing above very carefully. Note how there is very little material to work with where the hinged flap is attached to the box. However, you will find that when you apply the paste to the bookcloth, it will become quite malleable and can be stretched quite easily. For the hinged flap to operate correctly you will be leaving a gap of a quarter of an inch (6mm) between it and the bottom of the base.

1. As with the lid, place the base on the cloth, draw around it with pencil and then mark and cut the cloth out as shown (Opposite and Above). Apply paste to the cloth and carefully position the base on your pencil marks. Now position the hinged flap on the cloth. Leave 0.25″ (6mm) clearance between it and the base.

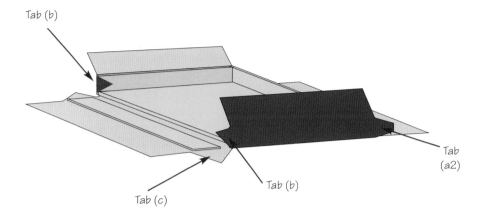

Tab (b)

Tab
(a2)

Tab (b)

Tab (c)

2. Begin, as we did with the lid, by covering each of the two shorter ends. You will observe that, in making room for the hinged flap, one of the tabs is now significantly smaller. (See Tab (b)). Use your fingers and your bone to stretch it around the edge of the side. Similarly wrap Tab (a2) around the corner. In both cases burnish the triangular piece of cloth into position to cover the corner completely.

3. Next wrap the two triangular tabs (Tabs (c)) over the hinged flap as shown above and (in position) below.

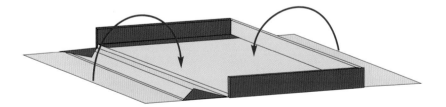

4. Finally, wrap the two remaining flaps over the longer sides to finish the box. Start with the flap opposite the hinged flap. Next pull the cloth over the hinged flap leaving it flat on your work surface. Using the edge of your bone folder, rub the cloth in the groove formed between the flap and the edge of the base.

Right: The finished base.

5. Finally, cut two pieces of cloth or paper to line the inside. These pieces should be 0.25″ (6mm) in from all the sides. (If you use book cloth rather than paper, it will be easier to work with, and will be more forgiving of any measurement errors.) Paste and attach it to the inside of the two components and then burnish it with your folder carefully and evenly. Place a protective sheet of clean paper over the inside of the lid and the base and weight them while they dry. This can take several days.

Right: The finished lid with liner in place

Right: The finished base with liner in place

Above and Opposite Page: It is easy to lapse into conventional thinking and simply assume that a plain white mat will suffice. Instead, learn from the past. This beautiful embossed mat is from the early 20th century.—why not try something like this? This mat was part of a total package which folded up into a self-contained envelope, the exterior of which is shown opposite. Anonymous image purchased at a garage sale.

MATTING PRINTS

This form of presentation is a kind of default standard in the world of photography. It is unclear how and why this is so. When you think about it, it's really quite silly. One purchases a quantity of beautiful board, and what is the first thing you do to it? You cut holes in it!

Often matting is also used as a cosmetic device to hide mistakes and poor craftsmanship. Poorly centered images, prints made carelessly with rough edges, etc., all look better when these faults are hidden under the mat. Often just knowing that the prints will be matted is enough to tempt one to make shortcuts. Instead, consider making the print a finished object in itself, needing no further embellishment. (See Page 129.)

However, despite these reservations, the practice persists for a number of very good reasons. Firstly, a crisp well-cut mat looks good! Secondly, the mat creates an air space between the print and the glass when the image is framed. Failure to leave such a gap can result in the print sticking to the glass, making it impossible to remove from the frame. Finally, a mat can protect the print if it is handled roughly or dropped.

In this section we will show how to cut a mat with very simple and inexpensive tools. These are within the reach of everybody's budget and pay for themselves usually after no more than two or three mats. The crucial tools are a hand mat cutter, in this case a Dexter brand cutter (although there are many other alternatives) and a heavy, well-made straight edge. Both are necessary. The cutter will not work with a regular slim ruler so do not be tempted to try as you will almost certainly slice a finger badly in the process. Excellent straight edges are sold by Light Impressions. Do not compromise on this purchase as it is a matter of personal safety. It should be at least a quarter of an inch thick.

The image to the right shows what you will need. The whole kit can be obtained for around sixty dollars. As mentioned before, a good quality, thick straight edge is the most important tool to acquire. Starting at the top left and moving clockwise we have: photo-corners, a small dish with a folded paper towel soaked in water (to wet the linen tape hinge), linen tape backed with water based adhesive, scissors a bone folder, a ruler, pencil, mat cutter, an eraser, a weight to hold the print in position while we attach the photo-corners and a straight edge. You can make the weight yourself. In this case six or so pieces of glass have been wrapped in paper. All of this sits on a cutting board. If you do not have one, a piece of regular cardboard will suffice.

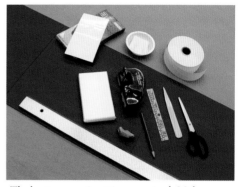

The key to success is getting organized. Make sure you have a large, clean workspace and all the tools you need at hand.

2. Here we see the hole being marked out on the back of the overmat. It is important to make the bottom margin slightly larger than the top. A perfectly centered hole may seem logical, but if you do this it will look low. The exact amount is a matter of judgement and experience. About three eighths of an inch (about a centimeter) higher than exact center is right for most mats. When drawing the margins also remember that, because the cut is bevelled ,there will be extra overlap on the image. Try not to make these marks too bold. You will need to erase them when you are finished. Ideally make the top and side margins the same. However, this is not always possible if matting different size prints to a standard size board. If this is the case, decide on a standard style and be consistent

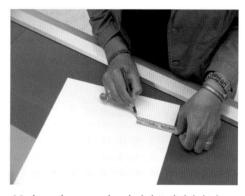

Mark out the mat so that the hole is slightly higher than dead center. If you center the print exactly, it will look as though it is low. Note also how the ruler is being used to mark the margins.

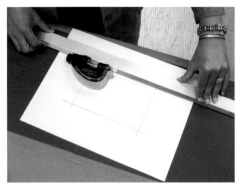

Start by placing the blade on the guideline and gently pushing into the board about and eight of an inch before the corner. Then align the straight edge parallel to the guideline.

Grip the mat cutter and make the cut. Success is more likely if you keep your eye directly over the cutter and move your body, and hence your weight, in unison.

The two pieces of board are attached by a hinge made of linen tape.

3. Get the mat cutter and slide the blade into the mat board. Insert the blade around an eighth of an inch (about 3mm) before the corner actually starts. When the cuts are made we will slightly overcut each of the corners. The blade is so thin that these cuts are barely visible. If you do not do this, the corners will not be sharp. After the blade has been placed in position, get the straight edge and place it adjacent to the mat cutter and align it so that it is parallel to the line you have drawn. You can, if you wish, measure the mat cutter's distance from the line but usually you can judge this by eye.

4. We are now ready to make the cut(s). The single best principle to remember is to keep your eye over the blade. If you do this you will find it easy to control the cutter, and by default, your body-weight will be in the optimum position. Hold the straight edge firmly and make the cut in one decisive movement. Remember to extend the cut over the edge of the corner, again about an eighth of an inch (3mm).

5. The front of the mat must now be attached to the rear. To do this we create a hinge using linen tape. This is easily obtained from an archival resource store such as Light Impressions, Talas or Gaylord. Place the tape on the side of the mat you wish to hinge. Using the scissors cut the tape about half an inch (one centimeter) shorter than the board.

6. You moisten the linen tape by using the dish containing a folded pad of wet paper towel. After moistening the front end, hold this end of the tape as shown. Then pull it over the pad while pressing down with the thumb of the other hand. If you cut a lot of mats you may consider buying a ceramic roller for this task. However, this simple solution works fine. Avoid creepy sensations in the mouth by resisting the urge to use your tongue!

Here we see the linen tape being moistened in the pad of wet paper towel. This activates the water-soluble glue. Use your bone folder to burnish the tape after attaching it to the boards.

7. The next task is to position the print in the mat. Place the print between the boards and align it carefully. A particularly nice effect can be obtained by cutting the mat about a quarter of an inch (5mm) larger than the border of the print. This reveals the printed border and gives you the effect of a frame within a frame.

Then fold the mat so the front and rear boards align perfectly. Carefully position your print under the cut hole.

8. Finally attach the print to the rear board. In the old days, prints were often dry-mounted to the board. This is not a good idea because if anything happens to the mat, say it is dropped and the corner damaged, then the print attached to it also suffers. Far better to use photo corners so if the mat should be damaged, or if you want to re-use it for another print at another time, you can easily and quickly remove the print. Note how the weight holds the print firmly in place while you attach the photo corners. These can often be very fiddly if not downright cantankerous to use, especially the larger archival corners that want to stick to everything, fingers included, other than the board.

Use the weight to hold the print in position and attach the photo corners.

As mentioned before, do some research—as Ecclesiastes would say, "there is nothing new." Here we have two mats working together. First there is an oval mat defining the edge of the portrait. This mat is then further embellished with an embossed rectangular mat. Anonymous image purchased at a garage sale.

This image was printed at the Center for Fine Print Research at the University of Western England, Bristol. The large scale print was carefully positioned on the sheet with generous amounts of white space all around. The finished object need only be hung on the wall. Image by the author, Falling Up, *2004. Actual image area of 29.25 x 24.5 inches on a 35 x 47 inch sheet.*

PRINT AS OBJECT

Finally, consider the advantages of printing your images in such a way that they need no further embellishment. The easiest way to appreciate this is to walk through the printmaking area of a school with a good etching department. You will notice that in such a place the images are printed on large sheets of beautiful paper. As such the images are self framing. They are gorgeous objects and need nothing else to make them look good.

I remember doing this at the school in Australia where I worked during the eighties. I would walk through the etching department and see one beautiful object after another. I would then return to my own photo department and in comparison, everything looked like it was printed on raincoats! (Such were the joys and despairs of chemical processing and resin-coated paper.)

Now that inkjet printing is so ubiquitous, there is no need to print on small pieces of paper, with narrow, even parsimonious borders. Use a decent-size sheet and think not about printing the image, but using the image to make a print. In other words, make the print a finished object. You will save much money by then not having to mat the image, your portfolio will contain more images than cardboard, and the impression you will create when you show your work will be that of a careful and considered craftsperson.

Above and Opposite: The Roman Baths, I and II, Bath, UK.
Images by the author, 2004.

CONCLUSION

There is a common misconception that growth is kind of a gradually ascending line—usually ending with an arrowhead pointing upwards, much like the forefinger of a seventies disco dancer, compelled by the beat to point at the mirror ball on the ceiling.

Nothing could be further from the truth. If anything growth is more like a staircase—and a poorly maintained, spiral one at that. There are moments of progress and in-spiration, and periods of minimal progress (even doubt) and consolidation. This is all perfectly natural. Consider the pro-cess of editing and presentation as an opportunity to reflect on what you have achieved, and devise a suitable strategy to pause on the bumpy slope long enough to say, "This might not be everything I have done, this might not be everything I want to do, but it is nevertheless something—something I can hold in my hand, share with friends and reflect upon and learn from in private."

Such hopes keep us going.

Above: Wells Cathedral, Somerset, UK. (Sea of Stares)
Image by the author.

BIBLIOGRAPHY

ARTIST'S BOOK HISTORY AND THEORY

Drucker, Johanna *The Century of Artists' Books*. New York: Granary Books, 1995.

Eaton, Timothy A *Books as Art*. Boca Raton, FL: Boca Raton Museum of Art, (n.d.).

Freeman, Brad (publisher) *JAB (Journal of Artists' Books)* Chicago: Center for Book and paper Arts. (Journal)

Holleley, Douglas *Digital Book Design and Publishing*. Rochester, NY: Clarellen, 2001.

Hubert, Renee Riese & Judd D. *The Cutting Edge of Reading*. New York: Granary Books, 1999.

Lyons, Joan (ed.) *Artists' Books. A Critical Anthology and Sourcebook*. Rochester, NY: Gibbs M. Smith, Inc., Peregrine Smith Books in association with Visual Studies Workshop Press, 1985.

Rothenberg, Jerome and Steven Clay, eds. *A Book of the Book: Some Works and Projections about the Book and Writing*. New York: Granary Books, 2000.

BOOKBINDING AND PORTFOLIO DESIGN AND CONSTRUCTION

Bodman, Sarah *Creating Artist Books*. London: A & C Black, 2004.

Cockerell, Douglas *Bookbinding and the Care of Books*. London: Pitman, 1901.

Johnson, Arthur W. *Manual of Bookbinding*. New York: Charles Scribner's and Sons, 1978.

Kaplan, John *Photo Portfolio Success*. Cincinnati, OH: Writer's Digest Books, 2003.

La Plantz, Shereen *Cover to Cover, Creative Techniques for Making Beautiful Books, Journals and Albums*. Asheville, NC: Lark Books, 1995.

Lewis, A. W. *Basic Bookbinding*. New York: Dover, 1957.

Smith, Keith *Non-Adhesive Binding. Vol. 4. Smith's Sewing Single Sheets*. Rochester, NY: keith smith BOOKS, 2001.

DESIGN AND TYPOGRAPHY EXAMPLES

Carson, David *2nd Sight.* Text by Lewis Blackwell. London: Laurence King Publishing, 1998.
Carson, David *The End of Print, The Graphic Design of David Carson.* Text by Lewis Blackwell. London: Laurence King Publishing, 1995.
Drucker, Johanna and McVarish, Emily *Graphic Design History: A Critical Guide.* Upper Saddle River, New Jersey: Prentice Hall, 2008.
Livingston, Alan and Isabella Livingston. *Encyclopædia of Graphic Design and Designers.* London and New York: Thames and Hudson, 1992.
Parr, Martin and Badger, Gerry *The Photobook: A History Volume I.* London and New York: Phaidon Press, 2004.
—. *The Photobook: A History Volume II.* London and New York: Phaidon Press, 2006.
Roth, Andrew (ed.) *The Book of 101 Books., Seminal Photographic Books of the Twentieth Century.* New York, NY: PPP Editions, 2001.
Rowell, Margit and Wye, Deborah *The Russian Avant Garde Book, 1910-1934.* New York, NY: Museum of Modern Art, 2002.

EXHIBITION DESIGN

Holleley, Douglas *Better Things.* Rochester, NY: Clarellen, 2005.
Malraux, André *The Psychology of Art, Volume I: Museum Without Walls.* New York: Pantheon Books, 1949.
Nairne, Sandy *Thinking about Exhibitions.* London: Routledge, 1996.
Newhouse, Victoria *Art and the Power of Placement.* New York: Monacelli Press, 2005
O'Doherty, Brian and McEvilley, Thomas *Inside the White Cube: The Ideology of the Gallery Space.* Berkeley and Los Angeles: University of California Press, 1976.

PHOTOGRAPHY AND EDITING

Berger, John *Ways of Seeing.* London: Pelican, 1972.
Cirlot, J. *A Dictionary of Symbols.* New York: Barnes and Noble, 1971
Jung, Carl *Man and His Symbols.* New York: Doubleday, 1964.
Smith, Keith *Structure of the Visual Book. 3d ed.* Rochester, NY: keith smith BOOKS, (revised 2003).
Szarkowski, John *The Photographer's Eye.* New York: Museum of Modern Art, 1966, 1980, 2007.
Tufte, Edward R. *Visual Explanations: Images and Quantities, Evidence and Narrative.* Cheshire, Connecticut: Graphics Press, 1997.

BOOKS, FILMS AND WEBSITES CITED

Anderson, Paul *Pictorial Photography, Its Principles and Practice.*
Philadelphia and London: J. B. Lippincott and Co., 1923.
Bayley, R. Child *The Complete Photographer.* New York: Frederick
A. Stokes Company, c. 1923.
Boswell, Robert Blan *The Dream Journey, the Econ River.* Orlando,
FL: Lulu Press, 2007.
Dahl, Lisa www. LisaDahlStudio.com/*DiscardedDreams.*
*Encyclopedia of Source Illustrations, a facsimile volume comprising
all of the 266 plates contained in The Iconographic Encyclopedia of
1851.* Hastings-on-Hudson: Morgan and Morgan, 1972.
Faber, Kiera L. (Director.) *Living Organics.* Rochester, NY: 2007.
Frank, Robert *The Americans.* New York: Grove Press, 1959.
Freud, Sigmund *New Introductory Lectures on Psycho-analysis.* New
York: Carlton House, 1933.
Holleley, Douglas *A Passing Show.* Sydney: Macquarie Univ., 1973.
—. *The Last Day of Luna Park.* (Portfolio.) Woodford: 1981.
—. *Paper, Scissors and Stone.* Woodford: Rockcorry, 1995.
—. *Love Song,* Woodford: Rockcorry, 1995.
—. *Past and Future Tense.* Rochester, NY: VSW Press, 1998.
—. *Re-reading the Book.* Rochester: Clarellen, 2000.
—. *Digital Book Design and Publishing.* Rochester: Clarellen, 2001.
—. *X.* Rochester, NY: Clarellen, 2003.
—. *Better Things.* Rochester, NY: Clarellen, 2005.
—. *Secrets of the Spread.* Rochester, NY: Clarellen, 2005.
—. *Veronica.* Rochester, NY: Clarellen, 2006.
—. *1 CE.* Rochester, NY: Clarellen, 2007.
Holmes, William and Barber, John W. *Religious Emblems: being a
series of Emblematic Engravings with written explanations, miscel-
laneous observations and religious reflections designed to illustrate
Divine Truth, in accordance with the cardinal principles of Christianity.*
New York: George F. Tuttle, 1860.
La Croix, Paul J. *Military and Religious Life in the Middle Ages and
at the Period of the Renaissance.* London: Bickers & Son, 1870.
Lyons, Nathan *Notations in Passing.* Cambridge, MA: M.I.T., 1974.
—. ed. *Photographers on Photography.* Englewood Cliffs, NJ: Pren-
tice-Hall, 1966.
Marker, Chris (Director.) *La Jetée.* 1962.
McCloud, Scott *Understanding Comics.* New York: Harper
Collins in association with Kitchen Sink Press, 1994.
Morgan, Willard D. (ed.). *1001 Ways to Improve Your Photography.*
New York: National Educational Alliance, 1945.
Nagy, Moholy *Telehor 1–2.* 1936.
Nelson, Jason www. secrettechnology.com/*gamegame/gamegame*.html

Platts, Barbara *I'm Still Learning Things I Ought to Know by Now!* Anderson Ranch, CO: 2007.

Reed, Dede *Blue*. Rockport: Maine Media Workshops, 2007.

Shaw, Tate, and Sallee, Andrew *God Bless This Circuitry*. Rochester, NY: Preacher's Biscuits Books, 2007.

Smith, Keith *Structure of the Visual Book*. 3rd ed. Rochester, NY: keith smith BOOKS, (revised 2003).

Ward, Lynd *Gods' Man*. New York: Peter Smith, 1929.

White, Minor *Mirrors, Messages, Manifestations*. New York: Aperture, 1969.

WEB RESOURCES

Blurb.com/ Print on demand site.

Booksmart.com/ Inkjet printing supplies and portfolios.

Clarellen.com/ Author's website.

Gaylord.com/ Bookbinding and archival supplies.

LightImpressions.com/ Bookbinding and archival supplies.

Lulu.com/ Print on demand site.

Lumierephoto.com/ Mats, frames, book publishing.

Loc.gov/copyright/ Information on most aspects of copyright law.

MuseoFineArt.com/ Printing papers and fabrics for hard covers.

Portfoliobox.com/ Stock and custom made portfolio boxes.

Sharedink.com/ Print on demand site.

Solux.net/ Gallery lighting systems.

Talasonline.com/ Bookbinding and archival supplies.

INDEX

ACKNOWLEDGEMENTS

TEXT EVALUATION AND PROOF READING:

Dr. Alison Nordström, Curator of Photography, George Eastman House International Museum of Photography and Film, Rochester, NY (Hereafter George Eastman House). Dr. Peter Stanbury, former Director of the Macleay Museum, Sydney University, Australia, Marjorie B. Searl, Chief Curator of the Memorial Art Gallery of the University of Rochester, NY, Professor Jan Kather, Elmira College, NY, Dorie Jennings and finally, Bob *Eagle-Eye* Rose, of VMI, Inc.

OTHER ASSISTANCE:

Mark Knopp, graduate student of the Visual Studies Workshop, for picture research and Carol Aquilano of the Memorial Art Gallery of the University of Rochester, NY, for demonstrating her mat-cutting skills.

COPYRIGHT PERMISSIONS:

All copyright holders are credited in the captions of the book. The author would like to especially thank the estate of Lynd Ward, the estate of Walter Chappell, the Memorial Art Gallery of the University of Rochester, NY, and the New York State Legislature, the New York State Council on the Arts, and the Arts & Cultural Council for Greater Rochester (for *Better Things),* The Cary Graphic Arts Collection, Rochester Institute of Technology, NY, Rick Hock, Director of Exhibitions, George Eastman House, for permission to photograph its exhibitions and to use other images by Barbara Galasso, and finally Sally Petty of the Research Center of the Visual Studies Workshop, Rochester, NY.

LONG TERM ACKNOWLEDGEMENTS:

Nathan Lyons, Founding Director of the Visual Studies Workshop, Rochester, NY, Joan Lyons, Founder of the Visual Studies Workshop Press, Rochester, NY, Frank Cost, Associate Dean, College of Imaging Arts and Sciences, RIT, Brian Segnit, Manager of Book Publishing, Xerox Corporation and my dear friend, Beverly Hettig. Thanks are also extended to all of my teachers, colleagues, students and friends who have helped me with my work, and taught me much, over many years.